A BRIEF HISTORY OF
BUCKTOWN

10/31/16

Marla &
 Steve,

Please enjoy!

[signature]

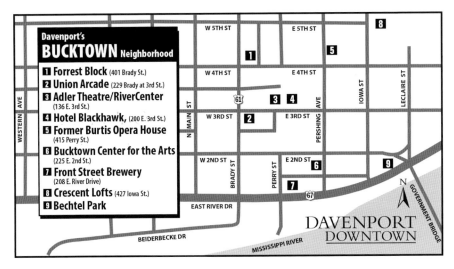

Courtesy of Douglas Teggatz.

A BRIEF HISTORY OF
BUCKTOWN

DAVENPORT'S INFAMOUS DISTRICT TRANSFORMED

JONATHAN TURNER

Published by The History Press
Charleston, SC
www.historypress.net

Copyright © 2016 by Jonathan Turner
All rights reserved

Front cover, top: Fritz Postel, a native German, owned a liquor store on West Second Street in the late nineteenth century. *German American Heritage Center, Davenport*; *bottom*: Second Street looking east in about 1940. *Doug Smith.*
Back cover, top: A Christmas parade on Second Street in the 1950s. *Richardson-Sloane Special Collections Center, Davenport Public Library*; *inset*: A bronze sculpture of Abraham Lincoln and a boy at Bechtel Park. *Author's collection*; *bottom*: A contemporary view of downtown Davenport. *Author's collection.*

First published 2016

Manufactured in the United States

ISBN 978.1.62619.909.5

Library of Congress Control Number: 2016936697

Notice: The information in this book is true and complete to the best of our knowledge. It is offered without guarantee on the part of the author or The History Press. The author and The History Press disclaim all liability in connection with the use of this book.

All rights reserved. No part of this book may be reproduced or transmitted in any form whatsoever without prior written permission from the publisher except in the case of brief quotations embodied in critical articles and reviews.

CONTENTS

Acknowledgements	7
Introduction: Defining Davenport	9
1: German Heritage Helps Make Bucktown	19
2: Battles Brew Over Alcohol	35
3: Brothels Keep City Lights Burning Red	48
4: Low and High Culture Flourish	59
5: From "King of Bucktown" to Arts Center	87
6: An Empire of Good Smokes Starts Here	100
7: An Iconic Hotel and Other Landmarks Restored	104
8: Enduring World Wars and the Depression	114
9: Downtown Undergoes Many Seismic Changes	126
10: Reclaiming History for New Living Spaces	139
11: Gateways to Bucktown Get New Attention	153
Epilogue: Bright Future Links Past to Present	159
Bibliography	165
Index	169
About the Author	173

ACKNOWLEDGEMENTS

This book—my first—is a dream come true. Since I started working for The History Press on another of their brief local histories in August 2014, it has been a daunting, overwhelming, fascinating and thrilling project.

Beyond my gratitude to the publisher for granting me this opportunity, it must be pointed out that this book would not be possible without the support and assistance of several people and organizations—the Davenport Public Library Special Collections Center resources and staff; Jane Simonsen of Augustana College, Rock Island, Illinois; Kyle Carter of the Downtown Davenport Partnership; Gene Meeker of Rejuvenate Davenport; Roy Booker of the *Quad-City Times*; Onnica Marquez and Chris Kastell of the Putnam Museum; Science Center, Davenport; Amy and Amrit Gill of Restoration St. Louis; staff at Hotel Blackhawk and the Adler Theatre/RiverCenter; Scott County Historical Society; German American Heritage Center, Davenport; the city of Davenport Planning Department; Bob King of the Classic Film Society; Andrew Glasscock of Alexander Company, MidCoast Fine Arts and Bucktown Center for the Arts; and my editor, Hannah Cassilly, for her wise counsel and guidance throughout the process.

Several people were kind enough to take time out for interviews for the book—Jane and Kyle (who are local Bucktown experts), Gene, the Gills, Donna Lee (another Bucktown aficionado who provided much assistance), Amy Orr, Bill Hannan, Heidi Brandt, Pat Bereskin, Rachael Mullins Steiner, Mary Talbert, Dana Wilkinson, Pete DiSalvo, Jim Thomson, John Ruhl, Larry DeVolder, Joe Taylor, Miles Rich and Doug Miller. A special thanks to

Acknowledgements

Doug (a Davenport native and active in many facets of city arts and business) for numerous interviews and constructive feedback after reading drafts of the book.

Davenport historian Doug Smith was endlessly patient and generous with his astounding collection of historical images and information. Historian Curt Roseman of Moline, Illinois; Jane Simonsen; and my sister-in-law, Susan Matt (an American history professor), also provided valuable input for the text. I'd like to dedicate the book to my family—my wife, Betsy, and sons, Alex and Josh—for their unending love and support, allowing this dream to become cherished reality.

INTRODUCTION
DEFINING DAVENPORT

It's a Friday night in Davenport, Iowa, and area denizens could start this spring evening by browsing the stylish art galleries at the downtown Bucktown Center for the Arts—with free admission, on this regular "Final Friday" event, residents and visitors can enjoy complimentary wine, cheese and other tasty snacks.

Barely three miles uptown, you could bask in the old-timey goodness of the *Bucktown Revue*, a monthly variety show in the spirit of *A Prairie Home Companion*, which celebrates life and culture along the mighty Mississippi River.

Capping off that Friday, you could head back downtown along the scenic river and choose to imbibe a dark Bucktown Stout at the popular Front Street Brewery, a Davenport fixture for years, boasting the original name of the current River Drive and the oldest brewpub in Iowa.

For all the fond nostalgia for and tribute to Bucktown, you won't see this moniker on a map of Davenport (population 103,000). But as it reigned notoriously over one hundred years ago as the city's infamous red-light district, the eastern edge of downtown (which borders Illinois) is again reclaiming a high-profile role as an entertainment epicenter—a place not only to eat, drink, be merry and entertained but also, increasingly, a locus of commerce and residence.

Roughly the area from Fifth Street to the river and east of Brady Street to the Government Bridge on downtown's edge, the Bucktown neighborhood buzzed feverishly in the late 1800s and early 1900s with a plethora of bars,

Introduction

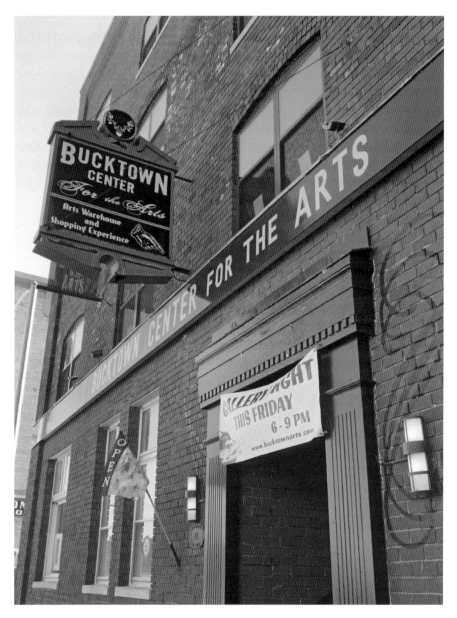

Bucktown Center for the Arts, 225 East Second Street. *Author's collection.*

brothels, theaters, dance halls and gambling dens. After years of neglect and abandonment, many historic buildings in the area today are finding new life in a dizzying variety of uses—from new bars and other unique businesses to sleek, modern loft apartments that honor their home's architectural heritage.

Introduction

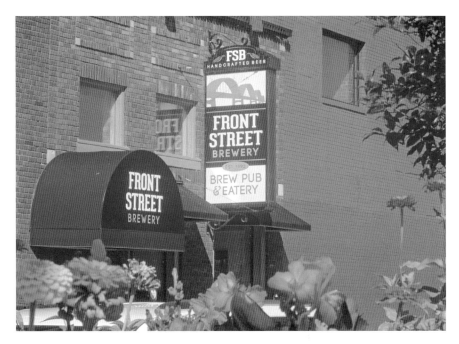

Front Street Brewery, 208 East River Drive. *Author's collection.*

It's estimated that in its most flourishing, debauched days, Bucktown contained no fewer than forty saloons and as many houses of ill repute.

In addition to its saloons and sporting resorts, Bucktown contained a number of variety theaters, including the Standard, the Bijou and the Orpheon. They operated wine rooms, and drinks were served throughout the performances, according to the July 20, 1924 *Davenport Democrat*. The programs often went into the early hours of morning.

At Brick Munro's notorious Pavilion, "the lights burned merrily and the bear cat, the Cubanois glide, and other 'classics' were in full swing from 8 o'clock at night until 7 o'clock in the morning," the *Democrat* said. "The whole east end after nightfall was one blaze of lights and the sounds of revelry, of discordant orchestras, mechanical pianos, broken-voiced sopranos, and shuffling feet floated upon the night air."

Davenport's gambling houses were also famous all over the West and included the Eldorado, the Senate, the Saratoga, the Ozark and many others. Continuous poker games running from three or four days to a week at a time were not uncommon.

"Legitimate" businesses coexisted with "illegitimate" ones in Bucktown, in the frontier aspect through the early twentieth century, says Jane Simonsen,

Introduction

An aerial view of the Bucktown neighborhood from 1915. *Doug Smith*.

associate professor of history at Augustana College, Rock Island, Illinois (across the Mississippi River from Davenport).

"It seems that the 'worst town in America' designation in 1903 becomes a real turning point for redefining Davenport, and Bucktown's identity gets sealed," she says of famous newspaper coverage, "to where it's no longer about German culture or men's 'sporting life' and really brings new issues about poverty and morality to light."

"In the late 1800s, early 1900s, this place was hopping. We really were the gateway to the West," Kyle Carter, executive director of the Downtown Davenport Partnership, says of Bucktown. "I mean, St. Louis has nothing on this. It's a history that's largely been forgotten, and that's a real shame."

"The Worst Town in America"

During Bucktown's bawdy heyday, the city's Catholic bishop, Reverend Henry Cosgrove, used his pulpit to call upon all citizens to join a crusade "against gambling, prize fighting, all-night and Sunday saloons and their social evil," according to the January 18, 1903 *Davenport Daily Republican*.

Introduction

"I have heard enough and I have been sufficiently told by men who travel and have the chance to know to convince me that we have a city here with worse conditions of immorality than any other in America," he said. "I believe from what I have heard that Davenport is the wickedest of them all. I don't like to sit still while it is going to the devil."

A January 21, 1903 editorial in the *Chicago Record-Herald* called Davenport the "Worst Town in America."

"The title of 'worst town in America' has been snatched from the brow of proud, imperial New York. No longer can the metropolis of the East boast of her supremacy in the matter of abundant and variegated forms of vice and crime. She is no longer a top-notcher in the lurid allurements of sin. She is just a plain, ordinary, quiet milk station, not even on the main line to perdition," the paper opined. "The center of vice and crime has moved from New York to Davenport, Iowa."

By 1894, Scott County was home to well over 240 saloons—150 of them within Davenport. Reverend William Lloyd Clark made his life's work to crusade through the 42 Bucktown brothels and saloons clustered within blocks of the Government Bridge.

In 1908, Reverend Clark wrote:

> *If I owned Hell and Davenport, I would sell Davenport and keep Hell. Davenport is saturated with rum and catacombed with houses of ill-fame from her vile levee districts to the top of her polluted hills. The city is filled with beer saloons and beer gardens. Is the home for dives of the vilest sort. Ragged children carry buckets of beer through the streets at all hours of the day or night. The streets resound with the drunken laughter of prostitutes.*

Floyd Dell (1887–1969)—an American newspaper and magazine editor, literary critic, novelist, playwright and poet—wrote of the Bucktown district:

> *One of the strangest parts of Davenport, of which I had a sufficient view from the outside, was the 'red-light district'—some streets down by the river, with houses of prostitution, in which plump women in flaming kimonos could be seen at the open windows, out of which came the sounds of laughter and piano-music, and into the doors of which well-dressed young men, talking gaily, entered.*

The *Davenport Democrat* in 1924 recalled two hundred saloons "flourishing in Davenport was the highest point of municipal saturation reached here in

Introduction

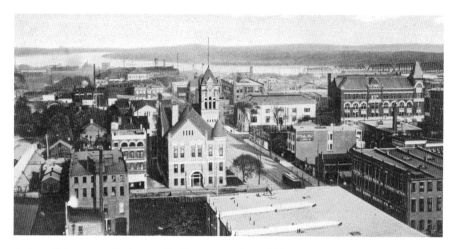

A view of downtown Davenport looking east, as it would have appeared in 1909. *Doug Smith*.

the old days before the successive waves of reform eliminated old 'Bucktown' and turned that old resort district into wholesale and business section. Before the reform Davenport was known throughout the country as one of the wettest and most wide-open cities in America."

"Most of those saloons ran wide open the year 'round, never closing for a single hour day or night," the paper wrote. "When the midnight closing law was first put into effect [in 1905], many of the proprietors had to rush to the locksmiths to order keys, never before having occasion to lock their doors."

Davenport and Bucktown's saloons also were a factor that drove what would become Grinnell College, founded in 1846 as Iowa College, from its original home in Davenport.

Among issues that made life difficult, the college (under leadership of abolitionist minister Josiah Grinnell) moved 120 miles west in 1859 since "Davenport was not a congenial home for the College, an atmosphere probably stemming from the institution's temperance sentiment which found no favor among the strong liquor interests of the town," according to a 1953 history by former college president John Nollen.

"But there was something worse than the saloon. There were things far worse," the *Davenport Democrat* wrote. "There was 'the dump' operated under the disguise of a saloon, which was no more than a rendezvous for thieves and other criminals. There was the all-night wine room, harboring men and women and girls and boys of tender years. Painted women freely roamed the streets of the city. Gambling houses and assignation resorts ran openly

Introduction

and without restraint." (Houses of assignation were maintained and used for illicit sexual encounters.)

Davenport historian Doug Smith says the city boasted many breweries before Prohibition and a large percentage of Germans, who were not going to allow an "unjust" law (restricting alcohol consumption) to limit beer drinking. The German population was no small contributor to Davenport mayor Ernst Claussen's making a statement in the 1880s that the state liquor ban would not be enforced in the "free and independent State of Scott."

"Scott County residents weren't about to stop their drinking because of Iowa laws. We simply ignored the law," Smith says. "It was as if we considered ourselves a separate state entirely." Bucktown isn't something to proud of, though, he maintains.

"Many of us are fascinated with the past, and as a local historian, my favorite hobby and pastime is collecting and sharing photographs and artifacts of the interesting history of my hometown of Davenport. However, for those who have a moral compass, Bucktown is something our city should be ashamed of—enshrined in neon lights," Smith says.

"Drunkenness, gambling, prostitution, fistfights, robberies and sinful injury to mind, body and soul is nothing to hold up as an attribute," he says. "However, things haven't changed much in Davenport."

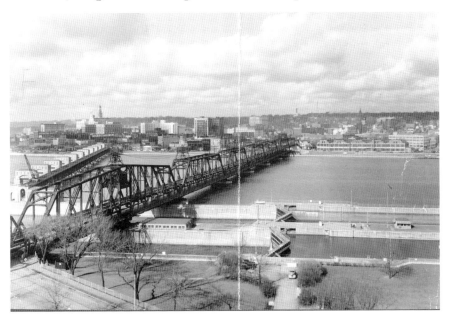

A view of downtown Davenport from the 1940s. *Richardson-Sloane Special Collections Center, Davenport Public Library.*

Introduction

Simonsen notes an intriguing theme is the confluence of German identity in Davenport and the red-light identity of Bucktown. "What's interesting about this is how, in the setting of a river town, the values of freedom, entertainment, music, and culture that the German immigrants bring with them become mixed with a—possibly more American—sort of individualism, entitlement, and leisure culture at a time when more women and men are flooding into the city."

These factors combined to "make Bucktown," she says, and they "also seem to be what's behind part of the resurgence today. These two rich strains evolve together in Bucktown—where some see freedom and culture, others see vice and immorality. Both are present and both key to its identity, but [they] often represent two different ways of seeing similar phenomena."

Bringing Bucktown Back to New Life

Over a century later—from the multimillion-dollar restorations of the 1915 Hotel Blackhawk and nearby 1931 Adler Theatre (a former RKO movie palace) to transforming vacant warehouse buildings—many developers have helped bring the Bucktown area back to pulsing life.

"There is a leap of faith and risk involved in all of that. These developers have thought the risk was worth it, and so far, it's been paying off—preserving these historic buildings that are an integral part of the fabric of the community," Carter says. Regarding generic commercial corridors, with heavy traffic, he cited a Davenport thoroughfare:

> *Everybody's got a Fifty-Third Street. Every community in the United States of America has a Fifty-Third Street. They serve their purpose. They need to exist, but it doesn't provide character.*
>
> *There's no soul, no uniqueness. Downtowns, and especially our downtown, define us as a community. Visit another community when you travel, and the first place you go is downtown. And if it looks like a dump, you assume the rest of the community—whether it's true or not—is a dump, too.*
>
> *You don't want that to be your impression to visitors or to residents. First impressions are valuable. They used to have bumper stickers in the '80s that said, "Last one out of the Quad-Cities, turn out the lights." That is no way to develop a community. Pride does matter.*

Introduction

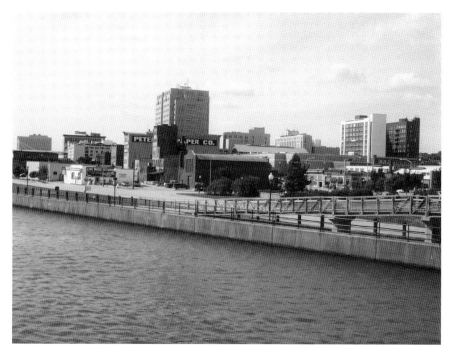

The Bucktown area in the present day. *Author's collection.*

> *You should have seen the faces around the ribbon-cutting for the Blackhawk [in 2010]. There's people almost in tears, looking at the Gold Room, and they remember their wedding that was there and saying, "Thank God this is going to be around for my kids." We still see residual benefit of these other buildings being turned around.*
>
> *You can build a million Walmarts, but it's not gonna set you apart. Everything in our downtown sets us apart—every little building, every little brick down there is unique to our little world, and that carries a lot of value.*

A history buff himself, Carter—in his downtown office across from the vacant 1920 Capitol Theatre—says of Bucktown: "It's so colorful, it's such cool stuff, and nobody knows it. Nobody knows how cool the history is."

"The Quad-Cities has not bragged about this enough—we were into the brewery thing way before it was cool to be in the brewery thing," Carter says of the metro area of four cities along the river in Illinois and Iowa and surrounding counties encompassing a total of nearly 400,000 people.

Introduction

"It's such a unique thing here, and the millennial generation loves it. Talk about retaining and attracting more talent—build more breweries," he says, echoing the intoxicating Bucktown flavor of the past.

"It was the birthplace of what became the Quad City Symphony Orchestra of today and the place where jazz was played on a regular basis," says film and media producer Doug Miller of Davenport, who worked at the old RKO Orpheum movie theater (which became the Adler) in the 1960s.

Brick Munro's Pavilion and Garden—the site where Bucktown Center for the Arts is today—was *the* hot spot where Al Jolson worked as a singing waiter before he became famous, Miller notes. Jolson talked fondly about his early days in Bucktown before he made it big, playing the nearby Burtis Opera House years later.

And near the spot where the first railroad bridge crossed the Mississippi River, the bustling railroads and river transportation put Davenport "at a big crossroads," Miller says. "People wanted something to do, and people were looking for things that they maybe shouldn't do since they were traveling and away from home. It went big about the same time frame as Storyville, the red-light district in New Orleans."

"Walt Disney got turned down for a job three blocks from here, and the film history of this area, it's just fascinating stuff, and it's stuff we should be taking great pride in," Carter says. "We should use that past as a draw. It gives Davenport identity, defines it. Talk about a badge of honor—who doesn't want to live in the wickedest city in America?"

How did Davenport get so wicked, and so colorful? Let's go back to the nineteenth century and visit Bucktown to find out.

CHAPTER 1
GERMAN HERITAGE HELPS MAKE BUCKTOWN

It was in the 1880s when the area east of Brady Street in downtown began to be referred to as Bucktown, according to University of Nebraska historian Sharon E. Wood.

The name might have referenced backroom poker games in saloons for which gamblers "passed the buck (buck knife) to indicate whose turn it was to deal, or more likely the bucks were the single men who populated the hotels, saloons and brothels scattered through the neighborhood," she wrote.

After 1893, city-regulated prostitution combined with accommodating alcohol laws turned Bucktown into an institution, Wood wrote, noting that several saloons crowded the neighborhood and it rapidly grew to include dance halls, bawdy theaters and gambling dens catering to the same male audience that visited brothels.

"The strength of the German population," said Wood, "meant that whatever Prohibition laws the State of Iowa passed were sure to be ignored. Beer was too central to German culture."

Against this backdrop, Wood portrayed Davenport as a magnet drawing women to leave their small towns and rural areas to come in search of work as clerks, factory hands and professionals. Davenport (with a population of around twenty thousand in 1875) was a walking city that could be reached by rail and river transportation.

Along the Mississippi River, the area was rich in natural resources and an ideal location for rail and water transportation. By the first decade of the twentieth century, three newspapers, including a German-language

Outside the German American Heritage Center, there is a bronze statue of *Germania* on the site of the city's first park. *Author's collection.*

publication, flourished in Davenport. Since its pioneer days, the city had had a library association, and in the 1870s, an academy of science (today's Putnam Museum) was formed.

Davenporters could see Lillian Russell at the Burtis Opera House or attend a performance of *Aida* or *Il Trovatore* there. The German immigrants who settled in Davenport introduced singing festivals, beer gardens, shooting contests and gymnastic societies to the Davenport cultural scene.

Donna Lee, of Rock Island, Illinois, who has maintained a website about Bucktown, described the area (around 1907) as consisting of low-lying buildings, warehouses, small shops, tenement houses and saloons. The heart of the district was Brick Munro's dance hall on East Second Street, where more than one thousand people a night would stop in and have a beer while listening to the singing waiters on a small stage. This platform was used by the professional vaudeville performers, who would frequently do their turns on these slight stages, Lee wrote.

"As a result, many people who normally would not have felt free to visit the district…could rationalize that they were just going to watch the shows," she said.

Rabbi Nathan, a character in Floyd Dell's autobiographical first novel, *Moon-Calf*, points out that "Port Royal [Davenport] has a quality of its own. I suppose this is partly due to the pioneers from New England, who brought with them ideals and a respect for learning; but it is more due, I think, to the Germans, who left home because they loved liberty, and brought with them a taste for music, discussion and good beer."

Settling Davenport

A great deal of the character and culture of Davenport (for good or ill) formed because of its significant German American population. It was incorporated in 1836 by a half dozen men led by Antoine LeClaire—an entrepreneur, translator and philanthropist born in the Michigan Territory to a French Canadian father and a Pottawatomie Indian princess. He named the city after his good friend (and cofounder) George Davenport, a trader for the U.S. government.

Yankee northeasterners helped settle Davenport and supported temperance while German and Irish settlers aimed to protect their right to imbibe spirits. Germans composed the largest group of settlers, raising the town's population from about six hundred in 1839 to eleven thousand in 1860.

One of the influential northeastern newcomers to Davenport was Dr. John Emerson, a Pennsylvania native and army physician who moved in 1833 to the federal military outpost Fort Armstrong on the Mississippi River island now called Arsenal Island. With him, Dr. Emerson brought his slave, Dred Scott, whom he had purchased in St. Louis, according to a Davenport Public Library history.

Emerson served as an assistant medical officer at Fort Armstrong between 1833 and 1836. He became friends with Colonel George Davenport and Antoine LeClaire but was transferred to Fort Snelling in the Wisconsin Territory. Dred Scott accompanied him and there married another slave. Dr. Emerson sent the Scotts back to St. Louis and returned there himself a few years later.

By 1842, Emerson had met and married Irene Sanford, and they decided to settle in Davenport. Leaving Dred Scott behind to take care of his St. Louis property and retired from the army, Dr. Emerson purchased the center lot on the south side of East Second Street, between Perry and Rock Island (now Pershing Avenue) Streets to build a house.

A Brief History of Bucktown

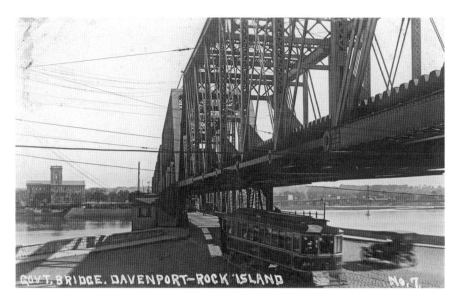

The 1896 Government Bridge, shown in 1910, in a view from Bucktown. *Doug Smith.*

He started to build a brick residence for his own use that he was never to occupy. Emerson died of tuberculosis on December 30, 1843, at age forty. His property, which included his slaves, was left to his wife and infant daughter in a trust, administered by Mrs. Emerson's brother, John Sanford. It had been Dred Scott's understanding that Emerson intended to free his slaves upon his death, but Sanford and Mrs. Emerson refused to do so. In 1846, Scott sued for his freedom in St. Louis, claiming that he was already a free man because he had lived in the free state of Illinois and in the Wisconsin Territory, where the Northwest Ordinance prohibited slavery. The trial took place in 1847, and Scott lost.

However, a new trial was granted later that year, and in 1850, Scott won freedom for himself and his wife. Mrs. Emerson appealed and won her case in the Missouri Supreme Court in 1852.

Scott brought the case to the U.S. Supreme Court, and in 1857, the high court ruled that any person descended from Africans was not a citizen of the United States and, therefore, could not sue in federal court.

Mrs. Emerson had married Calvin C. Chafee, an abolitionist politician, who was upset at discovering his wife's involvement in the Dred Scott case. Chafee, who lived in Massachusetts, contacted the Blow family of St. Louis, Scott's original owners, who agreed, as residents of Missouri, to emancipate their former slave.

Scott was freed by Taylor Blow on May 26, 1857. He died in September of the following year of tuberculosis, the same disease that felled Dr. Emerson.

"While Dred Scott did not win his fight for freedom in the courts, the ruling caused a great debate that spread across the nation," wrote Tammy Braden in an essay on Emerson and Scott. "Abraham Lincoln was soon elected president of the United States and the Civil War broke out, ultimately providing freedom to more than three million slaves. While Dred Scott did not see the impact of his case on the nation, he helped lead the way for the emancipation of every American slave in 1863."

It also led to the Fourteenth Amendment to the U.S. Constitution, adopted in 1868, extending citizenship to former slaves.

German Influences on Davenport

The strong German heritage of the community "formed the identity of Bucktown and its infusion of the arts into the everyday," says Karen Anderson, president of the Scott County Historic Preservation Society. "Art and music, for the common man, was central to the German way of life."

The emphasis on beer and alcohol, saloons, entertainment and even city-regulated prostitution, all stemmed from traditions in Germany, says Jane Simonsen, an associate professor of history at Augustana College (Rock Island, Illinois), who teaches women's history and gender studies at the private liberal arts school, including a course that studies the Wood book on Bucktown, *The Freedom of the Streets*.

"It's about the culture of leisure," she says, crediting Wood for this discovery. "The acceptance of drinking as social life, which was so wonderfully true in Germany. Brewing was part of the German cultural heritage—the beer garden[s], drinking on Sundays, wine at groceries. The Davenport mayor Ernst Claussen [who served from 1884 to 1889] was the son of Hans Reimer Claussen, a leader of Schleswig-Holstein's campaign for independence from Denmark."

The function of saloons was a place for men to eat, drink and socialize. So in areas where drinking, dancing, smoking and other components of male culture took place, there was the danger of prostitution, according to Simonsen. "Drinking culture helped to turn Davenport—and Bucktown—into a hub of entertainment, with theaters, dance halls and saloons."

In an article titled "The Most German City," Christoph May wrote that rising tensions in Schleswig-Holstein in the late 1840s led to the first

A Brief History of Bucktown

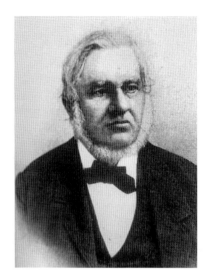

Hans Reimer Claussen (1804–1894). *German American Heritage Center (GAHC).*

political emigrations from Germany to Davenport. Nicholas Rusch, who later became an important German American political figure in Iowa as a Republican state senator and lieutenant governor, left Germany for political reasons in 1847.

From 1848 to 1850, in the Schleswig-Holstein province of Germany, a war was fought with Denmark for political freedom and national unity. After failure to win that battle, hundreds of Germans from Schleswig-Holstein (known as "the Forty-Eighters") immigrated to America to start fresh, many seeking refuge in Davenport.

The early presence of Schleswig-Holsteiners triggered a chain migration to Davenport in succeeding years. Carl August Ficke, Davenport's mayor from 1890 to 1891, remembered the sensation the letters from America caused in his hometown: "The letters described an earthly Paradise… [They] passed from hand to hand and were eagerly read. They were copied numberless times."

Two members of the five-man delegation that represented Schleswig-Holstein's interests before the Danish king in 1848 came to Davenport—Hans Reimer Claussen and Theodor Olshausen. They left Germany for good in 1851 to become well-regarded members of Davenport's German community.

Geological similarities between Davenport and North Germany were certainly another factor that made Davenport the favored destination for Schleswig-Holsteiners, May wrote.

Since the influx of Schleswig-Holsteiners continued through the 1850s, we can imagine how German-looking Davenport was by the end of the decade. It was no wonder that these immigrants would leave a huge cultural imprint on Davenport, soon making it the most German city in the Midwest, May wrote.

"A Gateway to the West"

Jim Leach, a former Iowa congressman and head of the National Endowment for the Humanities (2009–2013), said in a 2012 talk at St. Ambrose University, Davenport: "Davenport was a destination. A gateway to the West where the first passenger rail bridge across the Mississippi was constructed, it, along with St. Louis and Milwaukee, has long been considered one of the most traditionally German cities in America."

Among the reasons that Germans settled in Davenport were its rich farmland and open prairies, as well as its welcoming of immigrants from Schleswig-Holstein, who were decidedly intellectual and political in outlook, Leach noted.

The new Iowans, especially the Forty-Eighters, identified with advancing freedom in their old homeland, abolishing slavery in their new one and individual rights for all.

During the Civil War, Iowa produced the highest proportion of soldiers of any Northern state, over 20 percent of the state's males, and Camp McClellan in Davenport was the state's largest staging ground for recruits. A mile to the north of the camp, Annie Wittenmyer of Keokuk, who helped lead a national movement to upgrade medical care for the wounded, founded an orphanage for the children of fallen soldiers. She became the first president of the Woman's Christian Temperance Union.

Importance of Societies

Davenport daily life in the nineteenth century was dominated by German immigrants, in part because of the societies they formed.

The Turner movement arrived, building the foundation for the Sozialistischer Turnverein (Socialistic Turner Society), which aimed to promote freedom, education and physical well-being for all. The movement was also in favor of women's rights and other progressive social stances.

The Turner Society of Davenport focused on physical education and mental training—dealing with topics like temperance, religion and German-language instruction in public schools. Prominent Forty-Eighters like Hans Reimer Claussen and Matthias Rohlfs gave talks on a regular basis.

The dedication of the new Turner Hall in May 1888—at Third and Scott Streets, on downtown's west side (well outside the Bucktown

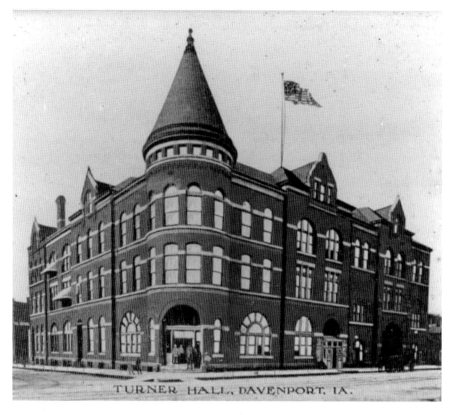

Turner Hall, on the west side of downtown. *German American Heritage Center.*

area)—"may have been proudest moment in the history of Davenport's Turner Society," May wrote, noting that it attracted the interest of all American Turners.

The three-story, turreted building was designed by German-born Frederick G. Clausen (1848–1940). Turner Hall included a restaurant, bowling alleys, a German theater, a library, an opera house and meeting rooms. Every community group, from the German women's society to the children's gymnastic class, met at Turner Hall.

Clausen's architectural firm (today's Scholtz Gowey Gere Marolf) is the oldest in continuous practice in the state of Iowa. He also designed many other notable downtown Davenport buildings, some on the fringes of Bucktown—including the Forrest Block, 401 Brady Street; Hibernian Hall, 421 Brady Street; and J.H.C. Petersen Sons' Store, 123–31 West Second Street (today's River Music Experience).

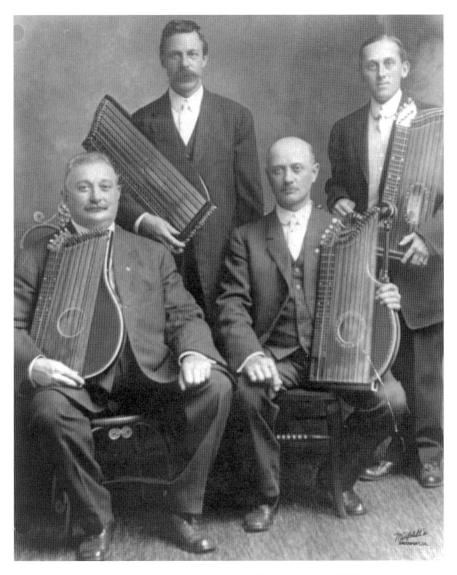

This zither quartet performed at the Grand Opera House in 1913. *GAHC.*

The new Turner Hall was the second largest of its kind in the nation and led to increased membership. In 1936, the *Davenport Democrat and Leader* summed up the role the society played for Davenport, calling the Turners "outstanding champions for those liberal principles which we in this country take for granted—free speech, free press and religious freedom."

Christoph May wrote that the Turners "were openly disdainful of the rawness of an American civilization which seemed to be without music, art, culture, or refinement. Thus, it comes [as] no surprise that the first German organization founded in Davenport was a Choral Society."

Matthias Rohlfs, who also brought the first piano to the city, founded this society in 1848, one year after his arrival in Davenport. In 1858, the society hosted a large singing event, drawing a regional field of twenty-seven singing societies to Davenport. The Singing Society worked to show German culture in a positive light.

Davenport's German societies "best illustrate the impact the Forty-Eighters had on their new home town on the Mississippi," May wrote. "The societies were the hubs of Davenport's omnipresent German life, providing newly arrived immigrants with a sense of home while at the same time promoting the Forty-Eighters' goals and ideals."

August Richter described the German societies by saying they were "all informed by that one spirit that sought the spread of education, freedom and progress, the fostering of the mental and emotional life and thus the highest possible happiness of all."

Active in Occupations of All Kinds

The German American leaders in Davenport (not only active in city politics) went on to have a profound influence on the city's culture—in theater, music and other leisure activities, most notably the alcoholic libations that caused such a ruckus. Like any city, Davenport reveled in both its highbrow and lowbrow culture, which attracted both champions and detractors alike.

Davenport produced several well-known German American politicians, including Henry Vollmer, Davenport's "boy mayor," who assumed that office at only twenty-six years of age and went on to represent Iowa in the U.S. House of Representatives.

Vollmer was born in Davenport on July 28, 1867, to German American parents; attended the public and high schools of Davenport; studied law at the University of Iowa and Georgetown University, Washington, D.C.; was admitted to the bar in 1889; and began to practice in Davenport.

He was a member of the city council first, at age twenty-two, and then served as mayor of Davenport from 1893 to 1897; as a member of the board of education from 1898 to 1901; and as corporation counsel in 1913–14.

He was elected as a Democrat to the Sixty-Third U.S. Congress to fill the vacancy caused by the death of Irvin S. Pepper and served from February 10, 1914, to March 3, 1915, failing to win reelection in 1914.

On April 23, 1893, the *Chicago Tribune* wrote that Davenport had the honor of having the youngest mayor of any city of its size in the nation. "He presides at Council meetings with a dignity beyond his years, while he is no novice to political experience," the paper said. "Mayor Vollmer is a fluent and forcible speaker, and for two years has been known as the boy orator of Iowa."

He also used his inaugural address to announce a new city policy of regulated prostitution (more on this in a later chapter), based in part on its publicly condoned legal practice in Europe, including in Hamburg, Germany.

German Americans played key roles in the varied economic life of Davenport. According to historian Carl Wittke, the Forty-Eighters were "the cultural leaven and the spiritual yeast for the whole German element." Their towering intellectual heft not only affected their fellow countrymen but also "influenced materially the political and social history of America during one of its most critical periods," he wrote.

Celebrating the Life of a Native Son

While some German Americans still played the zither (and a zither ensemble flourishes today at Davenport's German American Heritage Center), a lumberyard owner's son, Leon Bismark "Bix" Beiderbecke was born in Davenport in 1903 and celebrated his hometown with his cornet by creating one of the great jazz pieces of the twentieth century—"Davenport Blues." He became a jazz legend.

Bix's grandfather Charles Beiderbecke (born in Westphalia, Germany, in 1836) came to America at age seventeen. With his "persistent energy he sought prosperity and in time came to be known as one of the leading merchants and financials of Davenport," wrote Harry E. Downer in a history of Davenport and Scott County. "He did not tarry on the Atlantic coast but made his way to Indianapolis, Indiana, and for three years was employed in the post office.

He was sent by the government to Dubuque, Iowa, where he also held a position in the post office, but not liking that city, he remained for only a

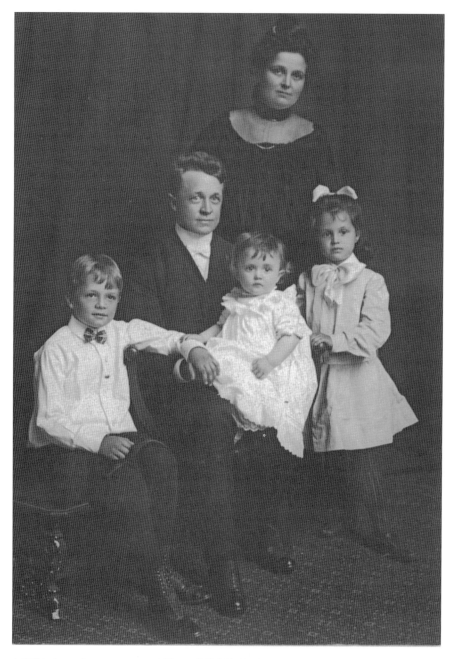

A 1904 photo shows one-year-old Leon "Bix" Beiderbecke on the lap of his father, Bismark. *Richardson-Sloane Special Collections Center, Davenport Public Library.*

short time before moving to Davenport. Charles entered into partnership as a senior member of the firm of Beiderbecke & Miller, wholesale grocers. They were located at the corner of Gaines and Second Streets and later on Second between Main and Harrison Streets.

Charles Beiderbecke was considered one of the leading businessmen of the city. He became president of the Iowa National Bank, which he helped to organize in 1890, continuing as chief executive officer until his death. He was also a director of the German Savings Bank.

"The people who know Bix, know he was a bit of a black sheep," says Janet Brown-Lowe, director of Davenport's German American Heritage Center. "His family loved him deeply, were supporters of the arts, but they didn't know what to make of his music."

Bix's mother was the organist at Davenport's First Presbyterian Church, and his parents were early supporters of the Tri-City Symphony. "Most prominent Germans were deeply into classical music," Ms. Brown-Lowe said. Bix's brother, Burnie, served in World War I and came back with jazz records. "He played them at home and Bix was transported," she says, noting that Bix taught himself to play piano and cornet.

Bix—who died on August 6, 1931 (in Queens, New York), at twenty-eight, and is buried in Davenport—became one of the city's most famous sons, and a strong influence in the jazz world. He was exposed to the burgeoning musical life force in Bucktown, in passing riverboats, and played in at least one concert at the Grand Opera House as a teenager.

A memorial jazz festival in Davenport was launched in his name in 1972 and attracts players and visitors from around the world every summer, on the weekend closest to the anniversary of his passing.

Andy Schumm, a Chicago trumpet and cornet player who emulates Bix's style, wrote that the young man with the horn "is quite possibly the most influential figure in the entire history of jazz....Bix had such an unbelievable intensity in his music." Calling Bix "obsessed with good music," Schumm wrote that he had "such a pure ideal about music. As a musician, I can only try my best to live up to it. When it comes down to it, Bix just was a rarity."

Bix—whose formal cause of death was pneumonia, but alcoholism was a contributing factor—gained fame by performing with Jean Goldkette, Bing Crosby and Paul Whiteman. Ironically, one of the bands he played and recorded with in the '20s was the Bucktown Five, but it wasn't based in Davenport.

The Bucktown Five got its name from that Chicago neighborhood, and—fittingly for jazz—it is linked with New Orleans (as is Davenport's

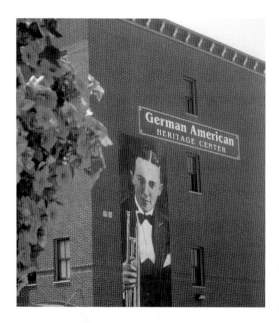

A portrait of Bix by Bruce Walters on the side of the German American Heritage Center. *Author's collection.*

Bucktown). Bucktown was the name of the settlement that grew on the shore of Lake Ponchartrain after the close of Storyville, New Orleans' notorious red-light district.

Coincidentally, New Orleans' Bucktown also was known in the late 1800s as an area with gambling houses, brothels and a lake view. "During the days of Prohibition, Bucktown was known for its speakeasies, houses of prostitution, and gaming dens," says a history at Pontchartrain.net. "Gambling was legal in what was known as 'the free State of Jefferson.' Bucktown was a rowdy, wide-open place where the barroom brawls were common."

Sound familiar? New Orleans's Bucktown was also one of the birthplaces of jazz, with such tunes as "Bucktown Bounce" by Johnny Wiggs and "Bucktown Blues" by Jelly Roll Morton.

OTHER IMMIGRANTS COLOR THE TOWN

Significant immigration to Davenport in the late nineteenth and twentieth centuries also has come from Ireland, Italy, India and Mexico, among other countries. In October 2011, a bronze statue on Second Street downtown was unveiled with a pair of four-ton stones from County Donegal, Ireland, depicting an Irish family leaving Ireland en route to America.

The memorial honors men, women and children who left their homes and families and settled in the Quad-Cities decades ago. Altogether, over one million Irish left their homeland during the Great Potato Famine of 1845–49 and dispersed to various points on the globe, including Davenport, according to the St. Patrick Society, Quad Cities. The society hosts an annual St. Patrick's Day parade that goes from Rock Island into Davenport.

Mexican immigration to Davenport and surrounding cities started with World War I, which caused a shortage of workers across the United States. Many local Mexican immigrants worked for the Rock Island Railroad, the Bettendorf Company and various Davenport industries.

In 1959, Henry Vargas conceived the idea of organizing local Mexican Americans of Davenport with the hope of achieving political strength with a united front, resulting in a local council of the League of United Latin American Citizens (LULAC).

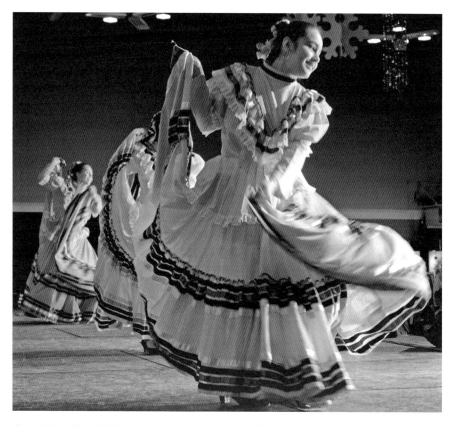

Quad Cities Ballet Folklorico celebrates the growing Mexican American heritage and culture of the area. *Ballet Folklorico.*

Most of the original members were second- and third-generation Mexican Americans whose parents had come to the area to work on the railroad, at foundries or at farm equipment makers International Harvester and John Deere.

The council met wherever it could, including at the YMCA and various taverns. In 1961, it leased a storefront on Perry Street in Bucktown and opened the LULAC Club. Meetings, other council business and many social events were held there until 1969, when it moved to its current location in Davenport's west end.

A separate Quad-Cities Mexican-American Organization was founded in 1981 to provide educational and cultural offerings to the community. It owns and operates the Col Ballroom in Davenport and helps fund scholarships and school grants.

In Scott County, the Hispanic population grew 42.6 percent from 6,445 in 2000 to 9,197 in 2010. Of that, Davenport had 7,277 Latino residents in 2010, 7.3 percent of its total population. Ballet Folklorico and Viva Quad Cities are two vibrant Hispanic groups in the area; Viva raises money for various activities, notably an annual fiesta, and offers scholarships.

Waves of refugees from around the world have been resettled in Davenport and the surrounding area over the past forty years, and former Davenport mayor Bill Gluba (who served from 2007 to 2015) was a strong supporter of welcoming refugees.

CHAPTER 2
BATTLES BREW OVER ALCOHOL

On a hopping Saturday night in 1922, federal agents and Davenport police joined to clean up the city—shutting down an opium joint, gin palaces and houses of ill fame; arresting twenty-four people; and confiscating a large quantity of liquor.

"Alleged Opium Joint, Hooch Palaces Raided," screamed the *Davenport Democrat* headline.

One, "Mrs. Brown's place," in Bucktown was "a rendezvous for drug addicts," and liquor obtained included four ten-gallon kegs of wine, nine quarts of gin, two gallons of moonshine whiskey and several jugs and bottles of wine, said the paper on November 19, 1922.

"This booze literally filled every crevice of the East Fifth Street house," the paper said, noting that even whiskey mash was discovered in a chicken coop. Davenporters really loved their liquor.

The popularity of alcohol and its opposing moral force—the temperance movement—became the primary social campaign (and affected the culture and business of Bucktown) from the settlement of Iowa into the twentieth century.

Those temperance workers, like their counterparts in other states, hoped that without liquor, they would achieve what the historian Andrew Sinclair described as "a world free from alcohol and, by that magic panacea, free also from want and crime and sin, a sort of millennial Kansas afloat on a nirvana of pure water!"

Alcohol consumption was a regular part of American life, and attempts to restrict it were viewed as violations of personal freedom and a damper

on the local economy, according to George McDaniel, St. Ambrose University professor emeritus of history. In 1830, the annual per capita alcohol consumption in the United States was 5.0 gallons, partly because water wasn't safe to drink and brewing was a way to combat disease, he said. Today, that figure is about 2.3 gallons per adult.

The first governor of the Iowa Territory—Robert Lucas, a Democrat—set out to deal with a catalogue of vices, especially those with the "most disastrous consequences…namely: gambling and intemperance," which, Lucas said in his 1838 inaugural address, were the "fountains from which almost every other crime proceeds."

Temperance on the Move

In 1839, the Davenport Temperance Society formed, and in 1842, the Scott County Temperance Society was organized. Meeting in January 1843, it described a Davenport where "the tavern and grogshop [had been] among the first places of general and nightly resort, [and where] could be seen about our streets and especially at certain places the staggering inebriate, the bloated and bloodshot eye, the blossomed nose, the cadaverous look, the parched and quivering lips and the tottering frame of the victim of intemperance." Now because of the work of the temperance society, "there were comparatively few who we can say are the worse for liquor."

The society admitted there were still a few places where liquor could be bought, but it hoped that soon there would be fewer.

In the last years of territorial Iowa, enthusiasm for temperance waned, but with statehood in 1846, proponents of temperance in the new legislature took up the cause again, McDaniel noted. In 1847, the legislature passed a local option law that would allow the licensing of the sale of alcohol.

The law provided for a countywide election to determine whether licensing would be permitted, and of the fifty counties then in Iowa, forty-nine (including Scott) voted against issuing licenses, a victory for temperance advocates.

In his inaugural address, Governor James Grimes called for a prohibition law that would "dry up the streams of bitterness that this [liquor] traffic now pours over the land." A few days later, Representative Amos Witter from Dixon in Scott County introduced a prohibition law, which passed in the Iowa House and Senate.

The law called for a vote by citizens to approve it, and its opponents claimed it could not be enforced and would create an atmosphere of falsehood in the state as proprietors sought ways to continue to sell alcohol. Over 48,000 votes were cast in the April election, and 25,555 Iowans, or 53 percent of those voting, voted to approve the law.

In 1858, in a concession to German immigrants in the state, the prohibition law was changed to allow the manufacture and sale of beer, cider from apples or wine from grapes.

In Scott County, those immigrants led resistance to the attempts to ban liquor in the state. "Spending Sunday afternoon at one of Davenport's beer gardens, Turner halls, or German theaters was an important part of the lives of German families," McDaniel said in a 2012 lecture at the German American Heritage Center. "Those activities helped define who they were as Germans and they served as a reminder of what they had left behind when they immigrated. Thus they had no sympathy for the moralizing Methodists, Congregationalists, Catholics and other reformers who wanted the millennial nirvana on the Mississippi."

At the annual convention of the Woman's Christian Temperance Union in Burlington, Iowa, in October 1878, a resolution was introduced to petition the Iowa legislature to pass a constitutional amendment to "forever" prohibit the "manufacture and sale of intoxicating liquors, including wine, beer, ale and cider." Within a year, other statewide temperance groups endorsed the idea.

In 1880, an amendment that prohibited the sale of any intoxicating liquors, including ale, wine and beer, was passed by both houses of the legislature, and two years later, the amendment passed a second time and was sent to the voters for ratification.

Prohibition with Public Opposition

Voters ratified it with a majority of 55 percent. Twenty-three counties voted against it, though, including all but Muscatine and Louisa of the Mississippi River counties.

The statewide referendum was barely over when opponents began efforts to nullify it in their communities, and in Davenport, with its large population of German Americans, this resistance became a way of life, McDaniel said. When told he had to enforce the law, Mayor Ernst Claussen replied that he

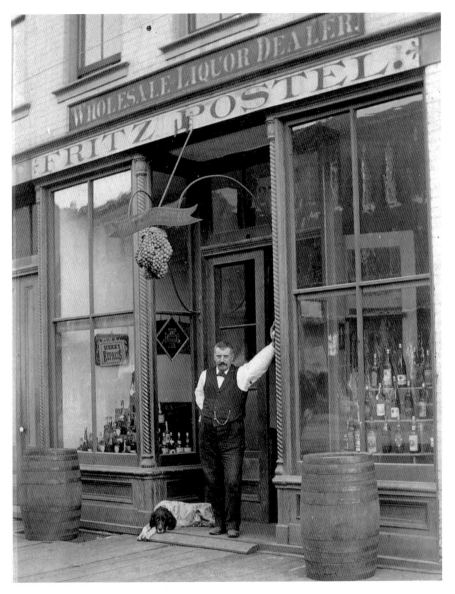

Fritz Postel, a native German, owned a liquor store at 427 West Second Street in the late nineteenth century. *GAHC.*

might have a duty to enforce the law but that it wasn't "his duty to make himself a smelling committee."

The mayor gave a name to this resistance. Echoing the battle cry of Schleswig-Holsteiners who had resisted Danish law, Claussen said,

"The liquor law of the State of Iowa will not be enforced in the free and independent State of Scott."

In Davenport, a business transaction between brewers and a saloonkeeper resulted in a lawsuit that brought down the state constitutional amendment for prohibition. The lawsuit revealed that the amendment had not been passed and ratified in the manner called for by the Iowa Constitution. In 1883, the Iowa Supreme Court declared the amendment invalid.

Trying Prohibition Again

A stronger prohibition law was passed in early 1884 that outlawed all intoxicating liquids—including beer, ale and wine, which had been exempted in earlier laws. However, pharmacists could still sell alcohol for medicinal, mechanical, culinary and sacramental purposes—which led some pharmacists to go to work for former saloonkeepers.

The new law went into effect on July 4, 1884, and there was open defiance of the law in Davenport. The city began to collect license fees from the two hundred saloons that operated in Davenport.

Governor William Larrabee was determined to enforce the law, and he called on each county to report how many saloons were in operation. Davenport mayor Claussen, who led a city that collected license fees from the saloons, replied, "presumably with a straight face, that he did not know how many saloons there were in Davenport," McDaniel said.

The drys were the dominant faction, and as the decade passed, prohibitionism and Republicanism became inseparable, according to McDaniel.

Under a GOP governor, liquor sales were controlled through a local option bill, which became known as the mulct law in 1895. Based on a similar law in Ohio, the mulct law provided that a tax of $600 be levied against anyone other than a registered pharmacist who sold liquor. Then they could continue to sell liquor and not be subject to prosecution.

The law provided that citizens of a county could call a referendum to decide whether the mulct would be offered. "The mulct was in no way construed as a legalization of liquor, thus satisfying the drys; at the same time it allowed local option sales of liquor, the goal of the wet moderates," McDaniel said. "The practical result of the mulct law was that by virtue of paying a tax the local government allowed the law to be broken."

In Davenport, tax revenue from the prodigious number of saloons and stores was so good that the city council eliminated the property tax in 1902, he said.

Davenport bishop Henry Cosgrove urged his priests to form temperance societies. At the end of their annual retreat in 1895, the priests formed the Total Abstinence Society, for which each pledged to refrain from use of alcohol. But in spite of the best efforts of temperance advocates, the problem continued. In 1903, Bishop Cosgrove called for a crusade against alcohol.

In a nod to his German American congregants, he said that wine and beer were "things…God has given us

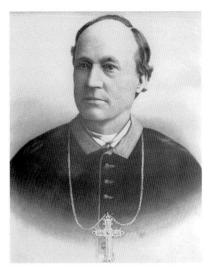

Reverend Henry Cosgrove (1834–1906). *Diocese of Davenport.*

to use." He more strongly objected to the saloon that stayed open Saturday night and far into Sunday, which he viewed as a violation of the Sabbath. In early 1903, he asked pastors, temperance societies, fraternal groups and the city council to demand enforcement of the laws in place and for a moral reform of society.

He said he liked Davenport, but he could not sit still "while it is going to the devil." Father James Davis, the pastor of Sacred Heart Cathedral, summed up the situation in Davenport in a sermon on Sunday, January 18. Davis said, "Intemperance is on the increase….Public officers seem powerless….Prohibition legislation is a failure….The saloons are open all day and night with wine room attachments and gambling devices of all kinds running without leave or license."

"Blissful Booziness" Continues

"It was a state of blissful, albeit defiant, booziness which continued on until 1900," the *Davenport Democrat* wrote in July 1924 about the city's two hundred saloons. "At that time two big Davenport breweries, the Independent Malting Company and the Davenport Malting Company, representing an

investment of three quarters of a million dollars, were running full blast. They had no right to exist under the law; literally, they didn't have a leg to stand on. But in the 'State of Scott' they didn't have any difficulty in putting their wares on the market."

By 1906, the mulct law was in operation in forty-three Iowa counties, which together contained a total of 1,770 saloons. Those saloons paid a total of $1,474,145.20 in tax revenue. In Davenport, the proceeds from the mulct tax, added to the license fees, made law-breaking a cash cow for the city, McDaniel said.

In 1905, Mayor Harry Phillips felt "the all night saloon and the wine room were bad adjuncts to the city," the *Democrat* wrote. "He was convinced that if local measures were not taken to remedy the evil, outside parties would come here and take drastic action. So he issued his famous midnight closing order."

On June 21, 1907, the *Rock Island Argus* reported that Senator J.A. Dearmand, an alderman-at-large in Davenport,

> *sent a shudder through the city council last evening by introducing a resolution providing that no more saloon licenses should be issued until the number of saloons here had fallen off to the proportion of one to every 500 inhabitants. He argued that the number of saloons in Davenport, Dubuque, and some other towns was so huge that it would lead to the adoption of a prohibitory law unless they became less dominant in local affairs.*

Davenport then had 188 saloons, 1 for every two hundred inhabitants. The council turned down the resolution by a five-to-three vote. In January 1908, 12 of the downtown saloons in Davenport closed their doors as a result of the movement for enforcement of the mulct law.

The temperance forces, after being rebuffed by the legislature in establishing marshals to enforce the mulct act, began to file injunctions on a large-scale basis, against all the saloons in a given community.

Taking on All the County's Saloons

On August 3, 1907, anti-saloon businessman T.H. Kemmerer and his attorney, Captain C.W. Neal, filed actions against every saloon (then 240) in Scott County.

At a meeting of the saloonkeepers, a committee was formed to negotiate terms with Neal on behalf of all of them. As negotiations did not produce

results, the association of German American clubs and societies (formed in 1906) called for all its member societies to join in a demonstration.

A massive pro-saloon demonstration was held in Davenport on August 15, 1907, at 8:00 p.m. A parade formed at Turner Hall at Third and Scott Streets, on the west end of downtown. It was estimated that five thousand people participated in the parade, and thousands more cheered them on along the way.

The parade was led by a band of 150 musicians, the largest number ever assembled in one band in Davenport, and marched downtown, through Bucktown. The *Democrat and Leader* called the parade orderly and respectable. "There was no attempt, not even of the slightest nature of radicalism or intimidation," it said.

At Washington Square, the crowd swelled to an estimated ten thousand and heard speeches by ex-mayor C.A. Ficke, Mayor Waldo Becker, Justice W.R. Maines and others, with most emphasizing that closings infringed on liberty, though reasonable regulation of saloons was acceptable and expected.

As negotiations continued, injunctions were issued against all saloons in Scott County, and the agreement required saloons to close at 10:00 p.m. on Saturdays and stay closed until 2:00 p.m. on Sundays.

The 2:00 p.m. Sunday opening was a big concession since the mulct law had called for all-day Sunday closings. So in all of Iowa after 1907, it was only in Scott County that any alcoholic beverage could be bought or sold on Sunday. That year, there were 212 saloons in Davenport.

From 1907 to 1909, George Cosson was special counsel in the state attorney general's office, and he later won a state senate seat (serving from 1909 to 1911), in which he challenged lax enforcement of liquor and vice regulations in Iowa. He secured enactment of laws for stricter enforcement, including one that established a recall mechanism enabling citizens to seek a judicial remedy against local officials who failed to uphold the law.

Another measure, known as the red-light abatement law, became a successful tool for closing segregated prostitution districts then flourishing in Davenport (in Bucktown) and Des Moines.

In 1909, a new law named for Senator Edwin Moon, a Democrat, set a limit on liquor licenses a city could issue to one for each one thousand residents. Exceptions were made for large cities, presumably like Davenport and other river cities, that current licenses would not have to be revoked to achieve the goal the law established. "Like the mulct law it was imperfect; nevertheless, it seemed to work," McDaniel said.

When the Moon law came into effect, Davenport was "sitting pretty," the *Democrat* newspaper said. "The city had a special charter from the state, and the Moon lawmakers had neglected to stipulate that their restrictions applied to special charter cities. So, having gotten rid of Neal and Kemmerer, who had been branded as mercenaries working for money, and money alone, the good people of Davenport sat back and had a delicious chuckle," the paper said.

By 1912, the number of saloons in Iowa was half the number in 1908.

Women's Suffrage and Temperance Join Hands

The reduction in number of saloons was not enough for the Anti-Saloon League and the temperance groups, which started to push again for a constitutional amendment to prohibit liquor in Iowa. Now that issue was joined with another social reform: women's suffrage.

The rise of the Woman's Christian Temperance Union (WCTU)—which formed in Iowa in 1874—and the cause of women's suffrage bolstered prohibition again since women and children were seen as the principal victims of alcohol abuse. Temperance and suffrage supporters joined forces; if women got the right to vote, prohibition's chances would be much stronger.

The Anti-Saloon League and suffrage supporters worked together to add suffrage and prohibition amendments to the Iowa Constitution. One important group in this coalition was the WCTU; the Iowa chapter had been pro-suffrage since its fourth convention in 1877.

Davenport's charter allowed it to escape the effects of the Moon law. But in 1913, an act was passed by the legislature that in Davenport and Dubuque, the number of saloons was to be reduced to no more than one per one thousand residents by July 1, 1915.

On May 14, 1913, the *Argus* reported: "Every saloon in Davenport wants to continue in business, 135 applications being filed with the Clerk. Of this number, there will be 31 eliminated by the provisions of the new legislation which makes the Moon law applicable to special charter cities."

On July 1, 1914, the *Argus* said: "Last evening 30 Davenport saloons closed their doors and went out of business in accordance with the state law.…The first 30 were closed a year ago, and 30 more will be wiped out a year hence, bringing the number down to about 45. The places are eliminated by the city council. Several were in the Bucktown area."

In January 1916, the mulct law was repealed, and the state prohibited "alcohol, ale, wine, beer, spirituous vinous and malt liquor."

Support for the right of women to vote rose until the 1913 Iowa General Assembly, when it passed a women's suffrage amendment and was adopted again in 1915. The ratifying vote by Iowa voters, all of whom were male, was scheduled for June 5, 1916.

Some opponents of suffrage said if women entered the public arena they would be "pulled down" to the level of men; instead, they should stay at home tending to their husbands and children. Others said women would vote as their husbands told them to, so they believed there would be little impact. The most common reason given against suffrage was that if women were given the vote, they would likely vote for prohibition, so Iowa liquor dealers and brewers were the most vocal opponents of the amendment.

Annie Wittenmyer (1827–1900), founding president of the Woman's Christian Temperance Union. *Putnam Museum and Science Center.*

Of the more than 335,000 votes cast, the amendment lost by 10,000 votes; 48 percent were for it and 52 percent against. The largest vote against it came in larger Iowa counties and in the Mississippi River counties with large numbers of German stock, such as Scott. When the General Assembly met again in early 1917, it passed the alcohol prohibition amendment for the second time and established October 15, 1917, for the ratifying vote by Iowa voters.

Many of the same groups who worked to pass suffrage the year before joined forces to pass a prohibition amendment. On election day, 78 percent of Scott County voters were against prohibition—the *Davenport Democrat* reported that only two precincts in the county voted dry.

As described by the newspaper, the upper wards of the city were "good and damp" while the lower wards (including Bucktown) were "soaking wet." In the state as a whole, fifty-six counties voted for the amendment; forty-three counties, including all Mississippi River counties, voted against it.

Move to National Prohibition

By the time the Iowa General Assembly convened in 1919, the U.S. Congress had passed the Eighteenth Amendment to the U.S. Constitution, outlawing alcohol, and Iowa became the thirty-first state to ratify it.

The next day, January 16, 1919, ratification by Nebraska put the amendment into the Constitution. Later that year, on June 4, Congress approved the Nineteenth Amendment, granting the vote to women, and sent that issue to the states. Iowa was the tenth state to ratify it, and within a year, it, too, was added to the Constitution.

As open defiance of national Prohibition during the 1920s shows, "no law or constitutional amendment would eliminate what the people would prefer to keep," McDaniel said, noting that "temperance advocates might have wanted a 'millennial Kansas afloat on a nirvana of pure water' [and] many citizens of the State of Scott joined the citizens of the state of Iowa in a journey to cross the dry desert to Nirvana, but found they were very happy to stop at the first oasis with a saloon."

Following Prohibition, Davenport historian Marlys Svenden wrote: "Resentment for the social do-gooders was strong and liquor continued to be available from basement stills or a sympathetic pharmacist. Hundreds of brewery workers lost their jobs and public morality was undermined by the hypocrisy or flagrant lawbreaking."

Bootlegging flowed through the Tri-Cities, and Prohibition agents made the area their base of operations for a wide district. Almost daily, newspapers carried stories of liquor raids and arrests in Davenport. In one home, agents uncovered the biggest stills found in Iowa up to that time, one of one-hundred-gallon capacity and the other of seventy-five gallons.

On May 4, 1923, the *Democrat and Leader*'s report on activities of a giant Philadelphia booze ring that shipped large amounts of grain alcohol and whiskey into Davenport for several months led to the arrest of a former Philadelphia man who was "district manager" for the ring.

On November 4, 1925, the paper reported that a Bucktown barroom at 318 East Third Street was disguised as a restaurant and its owner was jailed for violating the state prohibition law. The building was equipped with all the furniture and paraphernalia needed for a restaurant, with the exception of food. A search revealed a quart of gin, moonshine whiskey and other alcohol.

The same article noted the owner of a store at 305 East Second Street was raided again (it had been raided a month prior) by the sheriff and federal

Prohibition agents, who found eleven pints of moonshine and two one-gallon jugs of what was believed to be liquor.

Federal agents on New Year's Eve 1928 raided three Davenport places, including an apartment basement that contained 112 pints of home-brew and 4 quarts of the same beverage.

While preachers and evangelists like Billy Sunday railed against the "evils" of liquor, B.J. Palmer (then head of the Palmer School of Chiropractic) in January 1927 deemed Prohibition a failure and menace to society. Declaring he never consumed alcohol in his life, in a radio address, Palmer said: "There is no harm in anything in moderation. The evil is in the excess."

He claimed many politicians "voted dry and drink wet," calling them "disgusting." "Oh the hypocrisy, the chicanery, the deception that prohibition has bred in the body politic is appalling," Palmer said. Bootleggers are "merely conforming to the law of supply and demand."

"A government does not have the right to prohibit the ordinary social habits of people, any more than it has the right to prescribe their religious beliefs and to subsidize ordinary business pursuits," he said. "The best that can be done by government in regard to the social habits and customs of a people is to regulate and prevent excess misery, and injustice."

Former mayor Henry Vollmer said of Prohibition in the *Democrat*: "Graft and corruption prevail in every department of the government as a result of fanatical bigots to strong-arm the personal liberties and customs of the people."

On May 25, 1932, Nic Coin—"reputed king of Tri-City bootleggers," according to the *Davenport Democrat*—was shot dead on the street by two men in a black sedan near his West Locust Street home in Davenport. He had been convicted the prior December on several counts of liquor possession and was killed because he "squealed" and knew too much about the liquor business in the area, the paper reported.

On July 10, 1933, Iowa approved ratification of the Twenty-first Amendment to the U.S. Constitution, which repealed the Eighteenth Amendment and ended Prohibition. The vote in Scott County to repeal Prohibition in 1933 was 17,806 to 2,374 for repeal.

With the formal repeal ratified by the necessary three-fourths of states, on December 5, the *Davenport Democrat* editorialized: "Every citizen who favored repeal should now take it upon himself to discourage intemperance and bootlegging, and should do everything in his power to help the administration enforce the liquor laws to the letter. If that is done, liquor will no longer have its old time terror."

Following the end of Prohibition, the Iowa Liquor Commission's first approved Davenport store was in the old Roddewig Building north of city hall on Harrison Street beginning on July 2, 1934. The building was a wholesale liquor store in the 1890s.

Iowa's "blue laws"—alcohol regulations passed in 1934—banned the Sunday sale of alcohol statewide. In 1963, a liquor license was created allowing businesses to sell alcohol by the drink for on-premises consumption. In 1972, the term "grocery store" was redefined, allowing gasoline stations that sell a few grocery items to sell beer for off-premises consumption, and Iowa's legal drinking age was lowered to nineteen after decades of the post-Prohibition law being set at twenty-one.

In 1973, Iowa's drinking age was lowered again to eighteen, and businesses were allowed to sell alcoholic beverages on Sundays by obtaining a permit. By 1986, Iowa's legal drinking age had been raised back to twenty-one.

CHAPTER 3

BROTHELS KEEP CITY LIGHTS BURNING RED

In addition to saloons, brothels flourished in Bucktown in the late nineteenth century and, for a time, were even permitted through Davenport city regulation.

At the turn of the twentieth century, Davenport's east end had forty-two brothels, some forty saloons, a couple dozen dance halls and burlesque theaters with their wine rooms. Bucktown was Davenport's blazing red-light district, though it wasn't formally defined as such.

In the 1890s, "many of the businesses that would have been spread out—brothels and saloons—end up being concentrated in this area, because it had the reputation of where you go to have a good time," Jane Simonsen, associate professor of history at Augustana College (Rock Island, Illinois) says of Bucktown.

Davenport regulated brothels at the time, but they were not all concentrated in Bucktown. Owners had to pay a monthly fine to the city to operate, and prostitutes had to pass a health exam. Hotels were not regulated, and some women who came for one-night stands were likely to be arrested, Simonsen says.

The 1900 U.S. census showed that for every twenty-one women working in legitimate employment, one Davenport woman worked as a prostitute—nearly 4 percent of the female workforce.

"No longer subject to random arrests, bail and fines, or hardship of jail terms, brothel keepers had unprecedented stability," Sharon Wood wrote in *Freedom of the Streets*. "Customers also no longer feared arrest, exposure

and public humiliation, while health certificates issued by the city reassured potential clients regarding venereal disease."

Davenport felt that if men were patronizing prostitutes, the city could "make sure they have a clean bill of health and didn't take [disease] home to their white, middle-class wives," Simonsen says.

While many brothels were north of Bucktown, in the central part of the city in the 1870s, they were moving downtown, closer to the river, by the 1880s. Many were along Front Street (today's River Drive), near Fifth and Brady Streets and east of Brady in Bucktown.

Mayor Henry Vollmer (1867–1930), who served as mayor from 1893 to 1897, had his own law practice in Davenport at just twenty-two years old and was twenty-five when he was elected mayor. The European physicians he consulted "considered regulated prostitution a moral and medical necessity," in order to "limit debauchery and protect society from illness and excess," Wood wrote.

In his 1893 inaugural address, Mayor Vollmer said, "The scarlet woman walks the street of every major metropolitan city. Thinking men will admit that the best method of dealing with this evil is rigid regulation and control."

He said of gambling and prostitution, that legislation "against these evils never had done any good and a system of rigid regulation was needed," according to the *Davenport Tribune* of April 6, 1893.

Mayor Vollmer instituted a policy—similar to those in France and Germany—where prostitutes were required to be registered, pass health exams and make payments to the city. This accepts the idea that condones "men as sexual and women as fallen," Simonsen says.

Vollmer (who went on to represent Iowa's Second Congressional District in 1914–15) decided that prostitution was "natural" and that it was best to keep it healthy, Simonsen says. Similarly, the state legislature, realizing the futility of a total ban, passed the mulct law in 1894 to allow liquor sales, provided a tax was paid, in localities that permitted such sales.

If a single woman was working in Davenport in the late nineteenth century or a woman operated a business with her

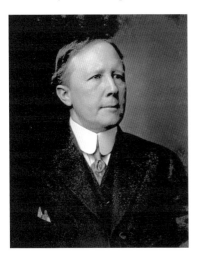

Davenport native Henry Vollmer (1867–1930). *Davenport Public Library*.

husband, it was likely that she was in Bucktown, Simonsen says, though that was not without drawbacks. "As the red-light district coalesces, this has implications for women working in the city, because it was hard to distinguish a prostitute from a working woman, in appearance and behavior."

The presence of prostitutes also affected the public image of women overall, creating the idea of "gender geography," Simonsen says, "that there are places if women crossed the line, they could actually be understood to be prostitutes. You didn't have to actually exchange money to be a prostitute; you just had to be in the wrong place at the wrong time."

Police prohibited the presence of unregistered women in brothels and required a minimum age of eighteen for prostitutes. Bucktown was not designated a red-light district, meaning brothels did not have to be within its boundaries. Wood wrote that after 1893, "regulated prostitution combined with the mulct law turned Bucktown into an institution."

"We know that Davenport was able to keep its entertainment district flourishing because it was willing to break the law regarding alcohol prohibition in Iowa," Simonsen says of the dozens of saloons in Bucktown. "Davenport pretty much said, 'We don't care,' in part because of the German heritage and in part because of lucrative financial reasons."

While many people think legalized prostitution in Davenport might have been based on Chicago because Chicago was so close, it was actually based on the European system, specifically the one in Hamburg, Germany, she says. "That's where the mayor's family was from. He was familiar with it."

Wood attributed Vollmer's actions to the influence of German Americans in Davenport, as well as the mayor's view of a "progressive" social policy. The longevity and acceptance of prostitution's regulation (among much of the Davenport public) stemmed from the aim to be "an honest and effective means of dealing with prostitution and from the financial windfall the city reaped," Wood wrote, "as a men's entertainment district came to flourish around the brothels."

A 2004 Yale Law School report cited an Arkansas banker in the late nineteenth century saying the red-light district was "a necessity like a sewer." The essay noted that the districts, like a sewer, "segregated filth and then hid this filth within specially contained areas. Abolishing the districts was akin to abolishing the sewer system—it would allow the pent-up filth of society to seep into virtuous residential neighborhoods."

In a 1984 essay, "There'll Be a Hot Time in the Old Town Tonight: Davenport's Bucktown," William Roba wrote that prostitution was a frontier aspect of the region in the nineteenth century, connected with the river

boatmen "on a spree." Newspaperman Charles Edward Rusell, who grew up in Davenport, recalled floating brothel houses "secretly hidden in the sloughs along the river so customers could cross from one bank to another boat," Roba wrote.

After the Civil War, prostitution appeared in different parts of the city, as dance halls were façades for whorehouses, and there were bawdy houses of ill repute like Black Hill's Den on Brady Street or Rachel's Place, located on the levee for rivermen who were in a hurry, Roba wrote, noting Davenport was not alone in allowing prostitution to become concentrated in a geographically defined area like Bucktown.

Facing Fierce Opposition Far and Wide

As with battles over alcohol, prostitution in Davenport faced strong opposition among social reformers, religious leaders and advocates for women's rights.

The Lend-a-Hand Club first formed in 1887 because there was "a broader concern with Bucktown as a dangerous place for women and the source of moral degradation," Simonsen says. Its building on West Second Street was on the outskirts of Bucktown.

It first began in a single room on the corner of Second and Brady Streets but in 1902 moved to more spacious quarters at 323 West Second Street, where the club could better meet the changing needs of its 750 members and the community.

Every day at noon, two hundred hot meals were served at an average cost of twelve cents in the club dining room. Lessons were given in language, music, homemaking and hygiene. There was a loan fund available for education and, for those temporarily in financial need, a savings program as well.

The club was organized by the King's Daughters, and its purpose was to help support, educate, counsel and train young girls and women, as well as provide social recreation. It specifically targeted self-supporting working women (including prostitutes and brothel owners).

When Lend-a-Hand women were opening businesses and hoping to make downtown streets safe and respectable for women to live, work and socialize, the regulation policy made the streets "sexualized space—men's territory," Wood wrote of Bucktown's prostitution. Some of the women who accepted the system "that consigned them to brothels found freedom they never before experienced, as well as profits of their own," she wrote.

Near the first Lend-A-Hand space was the office of one of Iowa's first female physicians, Jennie McCowen (1845–1924), who was also a suffragist, teacher, writer and one of the founders of Lend-a-Hand. She worked at the Forrest Block building, at Fourth and Brady Streets.

Among her proudest accomplishments was helping found the Lend-a-Hand Club, which promoted women's education and maintained downtown rooms where members could meet. It helped launch a number of businesses owned by women.

McCowen also helped form the Charitable Alliance of Women to argue for changes in policy to protect women. "They were worried about the situation that Bucktown put young working women in, at risk," Simonsen says. "The truth is that there sometimes weren't choices for poor women, that it was about money, not morality—but to do so would mean questioning the policy of toleration."

"Women are often the ones singled out as immoral ones," Simonsen says, noting that the "male leisure culture" upheld rights of men to do what they wanted. At Hibernian Hall, close by on Brady Street, there was a Turkish bathhouse upstairs, which is not noted on the historical marker on the building, Simonsen says. "When there was a crackdown on some of the houses of assignation, this was one of the places people got arrested," she says.

A large historic house at Seventh and Brady Streets (in a well-to-do neighborhood) was owned by Mamie Beauchaine, who made a lot of money running brothels, Simonsen says. Beauchaine rented property to prostitutes at the Slate House Hotel near the Government Bridge (currently a scenic park), on Front Street (today's River Drive), on Rock Island Street (today's Pershing Avenue) and at Sixth and Perry Streets.

The Slate House (on Second Street) was convenient for travelers coming from Rock Island on the Government Bridge and was close to the steamboat landing, Wood noted. Police arrested couples meeting there for an assignation and owners who rented those rooms.

At the Slate House and other such houses of assignation, "unregistered prostitutes or unmarried lovers could rent private rooms for sexual trysts," Wood wrote, noting that such relationships were outside the city's control in its regulation system. The police chief and the mayor opposed these houses as immoral but maintained their defense of regulating brothels.

Vollmer ordered the police to investigate and prosecute the houses of assignation.

Sexual transactions at hotels and other such houses were unregulated (and virtually impossible to regulate) because it "was just relationships people

Bechtel Park, on the east edge of Bucktown. *Author's collection.*

had," Simonsen says. "That was kind of a shady line—is that prostitution or not? No money was probably changing hands. But people assume it was some kind of prostitution."

The Woman's Christian Temperance Union also took on vice as a broader social issue, Simonsen says. "They were more concerned with family life, safe homes, and saw those kinds of areas where working men would go spend the family money.

"This issue of males spending time and money, and women working as prostitutes was problematic," she says. "The other problem was because women were paid very low wages, they were forced to go into prostitution. The WCTU tended to be more middle-class women trying to get rid of vice."

A similar Mississippi River red-light district took root around the same time and looked to Davenport for inspiration. *Empire of Sin* by Gary Krist tells the story of Storyville in New Orleans.

"Recognizing that any attempt to abolish vice entirely was doomed to failure (at least in New Orleans)," Krist wrote, "they hoped instead to

regulate and isolate the trade." Storyville was named for Sidney Story, the alderman who devised the plan. The district—first established in 1897—had 230 brothels by 1905. It lasted until 1917.

Thundering Condemnation from on High

Bucktown's saloons, theaters with wine rooms, burlesque theaters and city-sanctioned brothels led the Davenport Catholic bishop Reverend Henry Cosgrove to famously declare on January 18, 1903: "I have heard enough and I have been sufficiently told by men who travel and have the chance to know to convince me that we have a city here with worse conditions of immorality than any other in America, I believe from what have heard that Davenport is the wickedest of them all."

Bishop Cosgrove's crusade against vice focused criticism on late nights, Sunday hours and gambling and singled out Bucktown businesses where women worked as a special danger. The *Democrat* newspaper understood that saloons, gambling and prostitution "will be here for a long time to come, no matter what the efforts to extirpate them." The citizens of Davenport wanted matters regulated. "They don't want a puritan city and they don't want the impossible attempted," the paper said.

The *Davenport Democrat*, on January 23, 1903, said: "The town had been wide open for a time and although the mayor had shut down the slot machines and gambling rooms, wine rooms were flourishing and were being abused to an alarming extent. The youth of the city were being encouraged to live the life of the bohemian and the libertine."

"Young girls were being dragged down by drink and loose company. Indecent dances had been introduced and were being used at masquerades in many parts of the city," the *Democrat* wrote.

Dance halls agreed to close at midnight but remained open on Sundays, but the bans on women's presence were unenforced. Prostitutes continued to patronize establishments, Wood wrote.

By the fall of 1904, Mayor Harry Phillips decided to regulate gambling according to the model used for brothels. As long as games were honest and monthly fines were paid, the police did not interfere. "The district remained a lucrative site for entertainment businesses, pouring revenue into city coffers," she wrote.

The system of regulated brothels "created a kind of urban enterprise zone for sexual commerce" and cemented Bucktown's reputation "as an entertainment

district for men," Wood wrote. Gambling and various forms of sexual commerce took root in Bucktown. Dance halls and saloon theaters, operated by men and women with close ties to the brothel trade, "relied on young women—both patrons and employees—to attract men and their billfolds," she wrote.

The no-holds-barred nature of Bucktown was cited in the 2007 book *Citadel of Sin: The John Looney Story*, about the notorious, merciless Rock Island gangster (made famous in the graphic novel and subsequent movie *Road to Perdition*). Authors Richard Hamer and Roger Ruthhart describe Bucktown as a place where "gambling, prostitution and you-name-it all existed," and the violent Swede Anthony Billburg found work as a bouncer in saloons and brothels.

No one paid attention to his violent tactics and terrible temper. "The police didn't care," the authors wrote. "Davenport was then well known from New York to California as a gambler's paradise. High rollers gathered in Bucktown for games that lasted days," and Billburg gambled with the best of them.

Strong Opinions About Morality

In Davenport, with a large foreign-born population, there was fierce debate about the morality of prostitution, Roba wrote. Some felt there was little wrong since it was legal in Hamburg and other German cities.

William Lloyd Clark (1869–1935), one reformer, failed in his mission to eradicate Bucktown. He was a member of the American Protective Association and against gambling, prostitution and drinking; he blamed European immigrants for these social problems, according to Roba.

He started giving lectures in 1895 and was arrested one Friday night for selling pamphlets without a license. He was greeted by the crowd with yells, hisses and brandished pistols.

By 1907, reformers had intensified their attack on vice, as twenty injunctions closed down many saloons. In August 1907, attorney C.W. Neal stated: "Bucktown must go, for that is the instruction that I have received and I am only acting for my clients in the matter."

In April 1908, George W. Scott was elected mayor and proceeded to order all known houses of prostitution closed down. By 1909, the years of legalized prostitution would end in Davenport and across Iowa, as the state outlawed prostitution that year.

A 1911 article in the *Rock Island Argus* explained how the city was cleaned up, thanks in part to the Civic Federation of Davenport (organized in 1907) and its head, Reverend W.H. Blancke: "In the palmy days of Bucktown, vice

prevailed in all its worst forms, and the people of the city, at least the officers, had become so accustomed to it that they took it as a matter of course and refused to try to better conditions."

Public sentiment was against the federation. There were threats of destruction of property and even injury and death for the members, the *Argus* noted. Mr. Blancke's congregation, which remained faithful to him throughout, was warned it was unsafe to attend church because the structure was liable to be dynamited at any time. Yet the federation kept on working.

"It is not possible, Mr. Blancke said, to reform a community in a few weeks," the *Argus* said. "It takes years, for the people must be educated as the various steps are taken."

In 1909, the state assembly passed several new laws designed to shut down Bucktown and its counterparts in other river cities—one of which was a red-light abatement law, the *Argus* noted. "No longer would local authorities alone decide whether to prosecute brothel keepers, nor would juries have the power to decide guilt. Instead, any citizen could bring an action in court, and if evidence found, the court could issue permanent injunction to close down the business. In 1909, other laws closed down brothels."

It didn't impress a writer for the *Evening Times-Republican* of Marshalltown. A June 30, 1910 article headlined "Is Davenport a Hellhole?" asked, "Is the Capital right when it insists that a vast majority of a city like Davenport desire to perpetuate 'Bucktown' with its unspeakable dives?" It also cited the city's "wide open den of prostitution."

When the city was reformed, "the regulars in Bucktown just crossed the river to Rock Island, and Tony Billburg went along with them," *Citadel of Sin* says. Billburg owned saloons and employed prostitutes on Rock Island. He started his career as John Looney's attorney but eventually became his enforcer and intimidator.

Iowa was the first state to adopt a red-light abatement law in 1909, but by 1919, such laws were in effect in forty-one states. By the early 1920s, most red-light districts in the United States were eliminated.

Red-light districts in Davenport and New Orleans ended when America entered World War I. The navy shut down Storyville, and the Rock Island Arsenal's commanding officer ordered close all saloons within a three-mile radius of the installation. Without liquor sales as a front, Bucktown brothels retreated farther into the shadows.

The final death blow came in 1917, during World War I, when the federal government decreed that no brothel could operate within five miles of a military base.

Davenport's Infamous District Transformed

The *Davenport Democrat* editorialized on July 20, 1924:

> *One of the saddest spectacles ever witnessed in the city of Davenport was the exodus of the women from the red-light district.... Coming as it did without warning, it found the keepers and inmates of these resorts unprepared to move. Thrown out into the streets, destitute, homeless and in many cases without sufficient clothing, they were a sight to enlist the sympathy of the hardest hearted citizen who witnesses it. Many of the girls had known no other home for years. When they fell from grace, they were ostracized by their family and friends.*

A letter to the *Rock Island Argus* on August 15, 1922, noted that the neighboring Illinois city should

> *profit by the experience of Davenport. Second Street just west of the government bridge was known as Bucktown. It was an eyesore to the city of Davenport. One day it was closed, and for a time it looked as if that portion of Second Street, with its empty buildings and general neglect, would create a worse impression than when the dives thrived there. But it was not long until new buildings began to rise there, and now you would never know that Davenport had ever had a Bucktown.*

One former brothel still stands on the fringes of Bucktown—the Kimball-Stevenson House, 116 East Sixth Street, built from 1871 to 1873. According to the Scott County Historic Preservation Society, the Italianate mansion helped "celebrate Davenport's long tradition of sin by becoming one of its most notorious nickel 'Needle-beer' brothels (beer injected with 180-proof alcohol—through the cork)," a 2009 newsletter said.

"Gentlemen could sit in the elegantly appointed parlor while gazing into the strategically placed hall mirror—which perfectly reflected the 'ladies of the evening,' as they posed and preened upon the hall stairs," noted a walking tour promotion.

The house—the only former brothel on the National Register of Historic Places—is named for its original residents: Abel Kimball, who came west with the railroads, and Dr. J.E. Stevenson, who operated one of Davenport's earliest drugstores.

The house was home to railroad, banking and industry executives. From the early 1900s into the 1940s, the house served as a brothel, best known as Geraldine's Place.

The Kimball-Stevenson House, a former brothel. *Author's collection.*

From 1950 to 1980, the building housed apartments. In 1983, it was placed on the National Register, and having fallen into disrepair, in 1985 it was purchased by lawyer Mike Liebbe, who embarked on a total restoration. He was recognized for his work with a 1986 Historic Preservation Achievement Award from the Scott County Historic Preservation Society.

CHAPTER 4
LOW AND HIGH CULTURE FLOURISH

The strong contributions of German immigrants and their descendants helped form a rich cultural and educational history in Davenport, and the Bucktown area became home to a varied, pulsing life in theater, music and art.

In 1845, Davenport, Rock Island and Moline (then known as the Tri-Cities) each had its own municipal band, and Davenport had several small orchestras. The most important of these was the Jacob Strasser Orchestra.

In the winter of 1847–48, Forty-Eighter Matthias Jensen Rohlfs organized Davenport's first German singing society, the Liedertafel. Its successor organization, the Männerchor, survived until after the conclusion of World War I. German musicians, such as Jacob Strasser, Ernst Otto and Bix Beiderbecke, established reputations for excellence that live on to this day.

"The Germans were unparalleled in their participation in all musical groups, especially the choruses," reported a history of the Quad City Symphony Orchestra. The larger Männerchor was established in 1851. Other important choral societies in Davenport were the Mendelssohn Society, Philharmonic Society, Concordia Society, Schubert Glee Club, Davenport Madrigal Club and Harmonie Society (which was for quartet singing).

Many touring professional artists and groups came to perform in Davenport, including Victor Herbert, the Metropolitan Opera, the American Opera, the John Philip Sousa Band, the United States Military Band and the Chicago Symphony Orchestra under Theodore Thomas.

A Brief History of Bucktown

"Whether one preferred music in church on Sunday or in a neighborhood beer garden, there could be no question that during the twilight years of the nineteenth century, music held a central place in the day-to-day life of the community," Donald McDonald wrote in a 1989 history of the Quad City Symphony.

The largest music event in Davenport's history took place in July 1898, when the city hosted the eighteenth annual Saengerfest. It brought together ten local German singing groups as the United Singers of Davenport. The festival included 1,200 singers from Davenport and elsewhere in Iowa, as well as from Wisconsin, Illinois, Indiana and Missouri.

The four-day event attracted German Americans from throughout the Midwest, totaling 100,000 in attendance. And a new four-thousand-seat auditorium—Saenger Fest Halle—was built on West Fourth Street for the event. The wood structure was built for $4,500, and after the festival ended, the hall was used as a warehouse. In 1906, a second floor was added by new owners, and the building was dedicated as a dance hall called the Coliseum. It was destroyed by fire on October 21, 1913.

About eight blocks west of Bucktown, the Coliseum was rebuilt across the street from the old one, at 1012 West Fourth Street (this time brick was used as a safety measure) and reopened on October 27, 1914, with a long list of musical events. The arched Col Ballroom—on the National Register of Historic Places—still stands today, having hosted some of the biggest names in music.

Davenport's German American heritage led to the formation of one of America's oldest symphony orchestras, and the Quad City Symphony celebrated its 100th season in 2014–15.

The first members of the Tri-City Symphony Orchestra (many were German Americans) included teachers. Some played dinner music nightly at the Kimball Hotel. Many were active in community affairs, and with their strong musical tradition, they knew there was an audience eager to hear a local orchestra and that many of their friends were eager to play in one.

In early 1916, the organizers chose Ludwig Becker as the first conductor of the new sixty-member orchestra—a violinist who regularly came to the area as a recitalist and teacher. Born in Germany in 1873, Becker had a scholarship to the Berlin Conservatory for musical training. He became concertmaster of the Concert House Orchestra in Frankfurt and later concertmaster of the orchestra at Kroll's Garden in Berlin.

While there, he met Theodore Thomas, conductor of the Chicago Symphony Orchestra, who persuaded him to move to Chicago in 1896.

Davenport's Infamous District Transformed

Today's Quad City Symphony Orchestra, led by Mark Russell Smith. *Quad City Symphony.*

Shortly thereafter, he appointed Becker as assistant concertmaster, becoming concertmaster in 1909. Becker played for fourteen years with the Chicago Symphony and appeared as a soloist many times, and according to a Quad City Symphony history, he left to focus on a career as a concert artist and teacher, which brought him to Davenport.

Becker led the first performance of the Tri-City Symphony at Davenport's Burtis Opera House (at Fourth and Perry Streets) on May 29, 1916, before an audience of 1,200 people. The price of tickets for the first concert was $1.50 for a box seat, $1.00 for front-row balcony and orchestra seats and $0.75 and $0.50 for remaining seats.

All the music performed was from the nineteenth century, including Wagner, Schubert, Saint-Saens and Tchaikovsky—opening with Wagner's Prelude to "Die Meistersinger von Nurnberg." The *Davenport Times* wrote: "The Tri-City Symphony Orchestra scored one of the greatest triumphs in the annals of the local musical world."

Becker "handled his material with a masterly hand and as number after number was played, the applause grew in intensity until it fairly assumed the proportions of a cyclone of approbation," the paper said. After the concert, principal violist Henry Sonntag said: "The hopes and dreams of all musicians of the Tri-Cities have come true in the first concert."

At that time, the Tri-Cities was the smallest community in the country to have established a full symphony orchestra.

The first concert featured sixty musicians and two soloists and was the first and last concert of the first season. In addition to the "Meistersinger" prelude, the orchestra performed the Wagnerian aria "Dich Theure Halle," sung by contralto Esther Plumb; Schubert's Symphony No. 8 (Unfinished);

Saint-Saens' Concerto for Piano and Orchestra featuring pianist Robert MacDonald; a string elegy; a waltz; and Tchaikovsky's "Marche Slave."

The second season (starting in the fall of 1916) included four concerts in Davenport and two each in Moline (at the Illinois Theater) and Rock Island (Augustana College's gymnasium). Their first "pops" concert was held at the Davenport Coliseum on May 6, 1917.

The day before the concert, Ludwig Becker said in an interview with the *Davenport Democrat*: "Now that the orchestra is started, I am sure it will go on. The single concert last year was an experiment. The musicians showed what they could do. The result was magnificent."

The Burtis Acclaimed as the "Finest Theater"

At the orchestra's debut, the Burtis Opera House in downtown Davenport had already been open for forty-nine years.

J.J. Burtis (1811–1883), a dentist from New York, came to Iowa from Missouri, where he had served as a state legislator. In 1857, he opened the elegant Burtis Hotel at Iowa and Fifth Streets, which served as headquarters for military officers stationed at Arsenal Island during the Civil War. Iowa governor Samuel Kirkwood made the hotel his Civil War headquarters in 1861.

The Burtis House faced the railroad tracks, and its position next to the train depot allowed passengers to exit at the hotel's entrance. The Burtis catered to its guests at its original location until shortly after 1872, when the railroad built a new depot across town.

After the railroad changed, the old hotel later was incorporated into the Crescent Macaroni Company, and Burtis built a new hotel in 1874, next to his Burtis Opera House, which had opened in 1867.

Since its opening, the 1,600-seat Burtis Opera House had been said to be "the finest theater between New York and San Francisco."

Upon opening, the *Davenport Daily Gazette* reported on December 27, 1867:

> *The Burtis Opera House has been dedicated to Song, the Drama and the highest art purposes. The evening was propitious, and nothing prevented citizens from swarming in crowds to the beautiful temple. The seats in the Parquette and Dress Circle were filled with the wit and beauty of the city.*

> *The brilliant dome and proscenium "sunlights" and the gallery jets lighted up as brilliant a scene as eye would wish to look upon—at least as attractive a one as provincial eyes have beheld.*

The *Daily Gazette* provided further details about the Burtis: "The dome bears a handsome design, representing azure blue and sun-lit clouds with flying cupids...The frescoing is of the Flemish-Venetian school, airy and light, and relieved by appropriate fields in colors, painted with rare delicacy from purely original designs."

The proscenium was one of the largest in the country, and private boxes were "sumptuously furnished and draped with rich Brocatelle and lace curtains," the article said, noting, "Every precaution has been taken to provide against accident by fire."

Among many luminaries over its history, the Burtis welcomed author Mark Twain in 1869, actress Sarah Bernhardt in 1887 and her protégé Lilly Langtry the following year. Actor Edwin Booth appeared at the Burtis

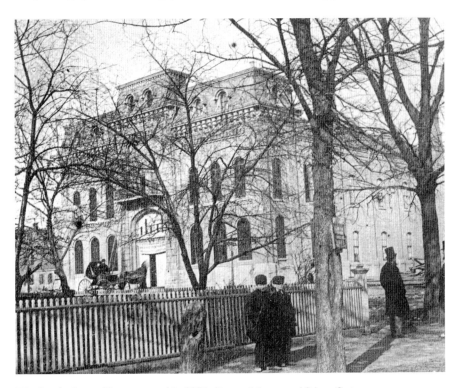

The Burtis Opera House opened in 1867. *Putnam Museum and Science Center.*

on April 21, 1888 (his younger brother John Wilkes Booth assassinated Abraham Lincoln in April 1865).

The house also hosted the finest homegrown talents, including Clinton-born Lillian Russell and Davenport's violin prodigy Florizel von Reuter.

During a Burtis show on January 29, 1869, theatergoers were introduced to a new mode of transport called the bicycle. Charles Kindt, the manager, also booked acts for the Grand Theater, opened in 1888 in the new Turner Hall at 513–15 West Third Street. The Grand and Burtis competed for the best acts on the touring circuit.

"In those days, Davenport had only 26,000 people—hardly enough to support two large theaters," reported the *Democrat* newspaper in 1955 on the city's golden age of theater. "Competition was so keen and attendance so great that Davenport became one of the great show towns in the nation. No booking agent would think of setting up a road company without playing Davenport."

Kindt agreed the Burtis would be used only on weekdays and the Grand only on weekends. The *Democrat* reported: "The agreement was a wise one. Both theaters prospered and the city was never without good entertainment."

On December 17, 1896, after a series of vaudeville acts was performed, Kindt came on stage to stand in front of a white sheet and announce that "the marvel of continuous views of human action were about to be shown on the white sheet hung up behind him," the *Democrat* reported. A machine in the balcony started clanking, and "lo and behold there appeared on the white sheet a band of charging horses," the 1953 article recalled.

Kindt bought the Burtis in 1906 and also booked acts for a dozen theaters in Illinois and Iowa, including Rock Island's Illinois Theater. Neighboring variety theaters (many in Bucktown), such as the Standard, the Bijou, the Orpheon and the Iowa Theaters, operated wine rooms, requiring their female entertainers to sit with patrons while not onstage. That was a line Kindt would not cross, and he maintained a reputation as a legitimate theater for his opera houses.

Eye candy was an occasional feature on the Burtis stage, as the *Davenport Daily Republican* reported on March 2, 1902: "American Burlesque will be the attraction at the Burtis Friday, March 7. This show has the distinction of being the leading burlesque show before the public. It is known for its beautiful women, fine costumes, costly scenery, and wonderful electrical effects. Headed by that wonder of all comedians, W.B. Watson, whose name is a guarantee that the show will rival, all others of the same calibre."

Davenport opera house patrons enjoyed touring companies of New York City shows, classical music and opera. The Olympic Theater operated in the 1880s, specializing in minstrel shows and working-class entertainment. By the mid-1890s, "more bawdy fare began to appear on Davenport stages," noted author Sharon Wood. On January 1, 1894, the Grand Opera House, in the west side building formerly occupied by the German Theater, advertised "Fanny Hill with her 40 English Blondes" in a burlesque, *Sin-a-Bad, Sailor*.

Eva Tanguay (known as the "I Don't Care Girl") performed at the Burtis in February 1907. In an earlier appearance in *Sambo Girl*, a newspaper reported that she "danced like a whirlwind gone mad. She traversed until the audience screamed with laughter. She acted but it was always farce."

Al Jolson, who sang at Brick Munro's pavilion in Bucktown in 1905, returned to Davenport in 1908 at the Grand Opera House and in 1917 at the Burtis as the star of the *Robinson Crusoe Jr.* touring company. Jolson—formerly a singing waiter at Brick's—once remarked from the Burtis stage, "You paid three bucks to hear me tonight. A couple of years ago, you could have heard me for the price of a beer down at Brick Munro's."

Tragedy at the Burtis

Tragedy struck the Burtis on April 26, 1921, when it was destroyed by fire. It was later restored to only about one-third of its original structure.

The *Cedar Rapids Gazette* reported, "An organized effort on the part of incendiaries to burn the business section of Davenport, was prevented here early today by the combined efforts of the fire departments of Davenport, Rock Island, Moline and the Rock Island Arsenal. Though the fires were got under control before they did a vast amount of damage, the Burtis Opera House was completely destroyed with an estimated loss of $100,000."

All the fires were started within an hour of one another and were within a radius of a block. Davenport police arrested Tolbert Olsen, a suspect who had singed and greasy hands. "Police are attempting to make a connection between Olsen and the oily waste, which Monday night was thrown, flaming, thru the window of the Penn Consumers' Oil station, 421 Fillmore Street," the *Iowa City Press Citizen* reported. "Five fires within an hour and a half, started authorities on a citywide search for an insane 'firebug' yesterday.… Unfounded rumors flew thick and fast thru the crowds who witnessed the flames gut the theater, last night."

Olsen admitted to the arson plot that destroyed the Burtis and badly damaged four other buildings. As a result, the Tri-City Symphony moved to Davenport's Masonic temple for its concerts, where it stayed until 1986, when the nearby Adler Theatre (a former 1931 Art Deco movie house) reopened.

In the 1920s, the orchestra also performed mostly at the Augustana Gymnasium on concert weekends, as well as occasional gigs at old movie theaters in Moline and the Elks Club. When Augustana's Centennial Hall opened in 1959, the concerts were swapped, with the Saturday night audience moving to Centennial and the Sunday matinee audience moving to the Masonic temple.

After the Adler renovation, it switched to host Saturday nights in Davenport, with Sunday afternoon moving to Centennial in Rock Island.

The last main tenant of the former Burtis Opera House was Tri-City Electric Company (hearkening back to the old name of the metropolis), which moved to Perry Street in 1979 and moved out in 2010 to the north end of Davenport.

"It was a beautiful building. Unfortunately, it wasn't the same building it was in the early 1900s," says TCE vice-president Larry DeVolder, noting that

A recent view of the former Burtis building. *Author's collection.*

the current green stucco finish was put on and extensive interior renovations were done to create offices.

"There were [a] number of employees that took to liking the fact that it was a historic opera house, and had a lot of character," he says. "But the inside pretty much, there's not a lot of original left."

The original second and third floors were destroyed in the 1921 fire, but the electric company did have second-story space, DeVolder says.

"We refinished the outside to have a nice appearance. The brick was deteriorating," he says of the original exterior. In early 2016, the building was newly occupied by a Department of Veterans Affairs office.

The former Burtis hotel next door went through several name changes—Kimball, Perry Apartments and then Vale Apartments—and eventually was demolished in 1993 due to its dilapidated condition. The building was empty for years and heavily deteriorated.

Future president (and Illinois native) Ronald Reagan lived in the former hotel on East Fourth Street in 1932 while working as an announcer for WOC Radio in Davenport. In an October 9, 1992 *Quad-City Times* column, Bill Wundram fondly recalled the building as the "Ritz of Davenport":

> *The wily owner of the Kimball had made a deal with the railroad to stop their passenger coaches half-way be-tween the Davenport depot and his hotel. Thus, the hotel was equally convenient in either direction. The famous, and the would-be famous, were attracted to the Kimball, and one could only wish that the registry books would someday surface in an attic or closet. What autographs.*
>
> *The registries would bear the names of Ulysses S. Grant, when he was general of the armies during the Civil War; Mark Twain, who made several appearances in Davenport at the old Metropolitan Hall; Ralph Waldo Emerson, the essayist; Stephen Douglas, the "Little Giant" who opposed Lincoln; Buffalo Bill Cody; and Lillian Russell, who was the Madonna of her day. Of course, in years later when the place was called the Perry Apartments, a boyish Ronald Reagan had an apartment on the top floor just beneath the mansard roof.*

The Kimball House Hotel was built in 1874 by J.J. Burtis as the "Burtis House," next to the Burtis Opera House. It was renamed in 1880 in honor of Abel Kimball, superintendent of the Chicago, Rock Island & Pacific Railroad.

Originally, passenger trains stopped at the hotel's backdoor, where guests were ushered in for a night's stay. The name of the hotel was changed to

the New Kimball Hotel in early 1908 after extensive upgrades, according to Davenport historian Doug Smith.

Among notable changes were the relocation of the hotel lobby and the addition of an office and store rooms. There were 125 guestrooms, all furnished in luxurious style. The floors in the office, rotunda and barroom were laid in terrazzo with mosaic borders. White Italian marble wainscot with a berde antique base formed a pretty contrast, and the office was trimmed in green oak finish, Smith said.

The second floor included a banquet hall with a stage for orchestras and speakers, as well as guest bedrooms and sample rooms. Hotel ceiling beams and wainscoting were made of oak, with ornamental pilaster and column capitals, and decorations were delft blue with Holland scenes, Smith said.

The bedrooms featured mahogany furniture, mammoth brass beds, rich carpeting and pretty lace curtains, which gave them a charming effect, he said. The hotel featured a Turkish bath, buffet and bar, and artesian water was used exclusively at its tables, Smith said.

A "Wide-Open Town"

While Bucktown in the early twentieth century was lively and diverse, the city's theaters also drew controversy for vice. While burlesque was banned in cosmopolitan New York City, it continued elsewhere, including Davenport.

"It actually had a reputation as a wide open town back in the olden days, that time of supposed innocence," Bob King of the Classic Film Society wrote in December 2014. "The city's rep was due mainly to the flouting of liquor and gambling laws, but our fair city also was home to a notorious burlesque house, appropriately named the Liberty [at 217 Perry Street]."

The Liberty is listed consistently in Davenport city directories from 1919 to 1923 and then sporadically from 1933 through 1944. A *Daily Times* article from October 29, 1937, said:

> *Liberty Theater, Burlesque House, Ordered Closed by Mayor, Many Complaints Are Received on Indecent Shows, Second Offense Results in License Being Revoked....Mayor Merle F. Wells announced today that he has revoked the license for the Liberty Theater, the only burlesque house in the Tri-Cities.*

Davenport's Infamous District Transformed

The Liberty Burlesk theater, 200 block of Perry Street, in the 1930s. *Davenport Public Library.*

> *Several months ago, a squad of Davenport police raided the theater after a policeman, posing as a patron, purchased a quantity of obscene literature.*

The manager said he would discontinue the sale of literature and would operate a "clean" show. The mayor explained that he had received numerous complaints of "indecent language by the barker in front of the theater."

The Iowa Theater (in the heart of Bucktown, 416–20 East Second Street) earned the city some of its wicked reputation in a 1903 brouhaha. The story of Anita Ray, a seventeen-year-old music hall singer who visited Davenport from the great metropolis of Chicago for a new performing job, raised the ire of Bishop Cosgrove and the press.

The *Davenport Daily Republican*, on January 14, 1903, reported that Miss Ray complained about the toughness of the Iowa Theater and its wine rooms, noting, "There are as many as 500 to 1,000 wine rooms or stalls in nightly operation in the city." The paper responded to her shock:

> *Assuredly, to the thinking part of the population, who have any knowledge of the existing conditions, Bucktown is depraved, deeply depraved. Has anyone ever suggested that Bucktown set up a high standard of morality, and has anyone any reason to be surprised if he learns of naughty things being done in Bucktown?*

And the Iowa Theater? Has it been the thought of any adult person in the city that the Iowa was a nice, quiet, decent, family resort? The Iowa is a theater of the low type—it does not profess to be anything else. It is fitted up with boxes, four to a side, with a number of girls who work the boxes selling liquor to suckers. The stage productions are not bad…

The theater of the sort of the Iowa is not new to Davenport, and the report of its existence should occasion no surprise. What is surprising is some people profess to be shocked and amazed at things which take place in this city. Mayor Becker talked with Anita Ray in his office for over an hour…He did not find her to be a tender, innocent thing. On the contrary, he discovered quickly that she was a rough talker and that she had an extensive and intimate acquaintance with the seamy side of life.

Anita herself related: "A number of rich young fellows from about town came to the theater to see the new singers from Chicago. They were drinking wine and were quite boisterous. They had two or three women with them. After one of my turns, they sent a note to the manager asking him to send me to the box in which they were sitting." She would not go, and the manager insisted and got very angry.

She refused, saying: "I had no money and no way of getting back to Chicago. At last I went to the police station and finally found the chief. I told him my story and he informed the mayor. Mr. Kindt, the manager of another theatre—a good one—got me a ticket back to Chicago."

In *Freedom of the Streets*, Sharon Wood wrote that Anita was forced to drink with the men at the Iowa since she was without friends or resources in Davenport and subject to the theater's regulations. She ended up living at the theater for a few days. The Iowa operated within a prostitution district, and its owner, Emma Woodward, had a well-known history of brothel-keeping.

The *Davenport Daily Republican* reported on January 22, 1903: "Intent on finding out for themselves whether or not Davenport is the wickedest city in the world, Aldermen Lunger and Klauer made a little pilgrimage into Bucktown Tuesday night and rounded up the more notorious places of the district. The things they saw were, according to reports, very numerous. They were directed to the localities where the red lights burned brightest." Mayor Becker acted to do away with wine rooms, which pleased Bishop Cosgrove.

Dr. C.H. Preston, the former city physician, said: "One need not be an extremist to be in hearty accord with Bishop Cosgrove in his declared

crusade against the forces of immorality in our fair city, and every good citizen must ask himself seriously: 'What can I do to help?' Whether or not Davenport is exceptionally bad—and I doubt if such is the case—yet it cannot be questioned that the drinking and gambling resort and the brothel are and have long been working fearful havoc among the young in our midst. It is high time that determined, organized efforts were made to at least put them under strict restraint."

On January 28, 1903, in the *Chicago Record-Herald*, Anita Ray said Davenport was a "little hell," the toughest place in America:

> *Chicago is a paradise when compared to the Iowa town....If it is true that God has forsaken Chicago, then He has never even visited Davenport, Iowa. For to one who experienced what I did in that Iowa city, there can be but little doubt that religion and the Divine hand never touched Davenport.*
>
> *For a town of this size, there is more vice than in any other city in the country. Why do I say it? Because I have seen it; I have experienced a week of it. and nothing that has ever happened in my life will ever again make such an impression on me as did this one week.*
>
> *The Davenport music halls are patronized by the sons of the wealthy houses, who carouse and spend money for the special purpose of getting the young girls drunk. They spend hundreds where the Chicagoans spend one dollar. They spend their nights in carousal, their days in slumber. Work they know not. Their unbridled debauchery goes on unhindered by police or authorities. The police make no attempts to stop it. They know that girls are ruined and their lives busted every night, but they do not interfere.*

The *Rock Island Argus* reported that the Iowa Theater was to be converted into a dance hall exclusively. "It was conducted as a vaudeville house, with beer between acts served to the audience, but since the enforcement of the new fire protection regulations, the Stage performances have been abandoned," the paper said. "The management is now having the stage boarded up and it will enter into competition with Brick Munro's and other dance halls that keep Bucktown humming at night."

On February 2, the *Dubuque Telegraph-Herald* said: "While the closing of the Iowa has met with almost universal approval, the conditions at the Orpheon are just as bad. The doors of the wine rooms at the Orpheon have been removed and the faces of the men and women who frequent these apartments are revealed to all, but under another name, rooms with a greater degree of secrecy are to be found in the building."

A Brief History of Bucktown

In *Freedom of the Streets*, Wood wrote that many Bucktown saloons had dance floors that employed women to dance with customers. After the mulct tax (adopted in 1894) imposed financial pressures on saloons, some expanded their business to "take advantage of Bucktown's growing regional reputation as an entertainment district for men," she wrote, noting five saloon-theaters and dance halls opened in Bucktown between 1900 and 1902, four of them along East Second Street.

Other Theaters Offered Busy Bucktown Nightlife

The following other theaters kept Bucktown humming at night:

Arc	129 East Third Street	Opened and closed 1913
Bijou	218 East Second Street	Opened and closed 1907
Hobson	217–19 Perry Street	Opened and closed 1896
Lyric	217 Perry Street	Opened and closed 1913
Mini Cinema	16–401 Brady Street	Opened in 1973 and closed 1984 (at that time, a small storefront theater showing porn films)
Mirror	129 East Third Street	Opened in 1911 and closed 1931
Orpheon	217–19 Perry	Opened in 1903 and closed 1908, this vaudeville theater later became the Princess and then the notorious Liberty burlesque house, and later the Rialto in the 1920s.
Royal*	127 East Third Street	Opened 1911 and closed 1912
Standard	416–20 East Second Street	Opened 1907
Strand	329 Brady Street	Opened 1916 (formerly the Unique Theater in 1914–15)

*(This theater was located next to the Mirror. Two blocks to the west there were two more side-by-side theaters, the Casino and the Family. At one time or another, there was at least one theater on each block of Third Street from 100 East to 500 West. After the demise of silent film, fewer features were made, fewer theaters were needed and there was never such an abundance of theaters again, according to local film expert Bob King.

Davenport's Infamous District Transformed

There was major growth in downtown theaters from 1906 to 1918. Most of the theaters were narrow and deep, a configuration required by the premium value of commercial footage on downtown streets, according to a 2010 article by William Perry and Bob King in the magazine *Films of the Golden Age*.

In the 1930s, Davenport had eleven theaters, fewer than the silent film and vaudeville era before then. Between 1910 and 1930, Davenport had dozens of theaters open and close. But when sound was introduced to the movies, vaudeville began to die and theaters closed, the article noted. Fewer films were made after the silent era, and fewer theaters were needed to show them.

"To some extent the movie industry was 'Depression proof' since entertainment was always needed," the authors wrote. Downtown's Third Street was "the entertainment axis of the city in those days, boasting both of the town's 'palaces'—the RKO Orpheum on East Third and the Capitol on West Third. Just to the west of the Capitol was a large vaudeville house, the Columbia, which later became the Esquire when it switched to film."

Other theaters on Third Street included the Garden, between the Orpheum and Capitol, and a block west was the Family Theatre, an old vaudeville house that was an early film theater beginning around 1907. It had closed down by 1929 with the decline of vaudeville and silent movies but reopened in the late '30s as the State Theater, showing films.

"While it lasted, the Mirror was the place for thrills, chills and westerns," Perry and King wrote. Admission was five cents for kids and ten cents for adults who didn't want to pay higher prices at the RKO or Capitol.

They called the Liberty Davenport's "shame," a "bump and grind burlesque house powered by a dozen or so tawdry-looking girls wearing little as they flirted, kicked and danced to the beat of loud drums and tinkling pianos for the amusement of seedy men and callow boys." The Liberty was "a false passport to manhood and some circles," they wrote. "Yet Davenport looked the other way and took solace in its legitimate theaters, which offered strong heroes and beautiful heroines."

By 1941, people had more disposable income than ever, and theaters were filled. "Even after the war, theater attendance remained high, but a new threat was looming on the horizon," the article said. In 1949, television came to Davenport (and the nation), and the number of theaters as well as attendance declined with TV's rise. Some theaters responded by enlarging their screens, using stereo sound and showing more Technicolor films.

"The crowds that once thronged Davenport's powerful retail axis along Second Street gradually disappeared, and the old theaters were dying by the

early 1970s," King and Perry wrote. Shopping malls and other retail centers also drew people out of downtown, as did new movie theaters that opened in Davenport and Bettendorf shopping centers.

Chiropractic Developer Started on Stage

While the city was making adjustments in its entertainment scene, Davenport became the birthplace of chiropractic care in 1895, when D.D. Palmer performed his first spinal adjustments (at Second and Brady Streets) and became home to Palmer College of Chiropractic. His son, B.J. (Bartlett Joshua), was active on the vaudeville stage in the years before taking over the school in 1906.

In 1898, at age sixteen, B.J. met Professor Herbert L. Flint, a hypnotist who came to lecture in Davenport and put on "vaudeville hypnotism shows," according to a Palmer biography, *B.J. of Davenport: The Early Years of Chiropractic*. B.J. performed with Flint in Davenport and other cities, and biographer Joseph Keating Jr. speculated that the traveling troupe experience aided B.J.'s "ability in assuming control of his father's business so successfully and the showmanship talents so much in evidence throughout his career."

Flint's touring vaudeville/hypnosis company was one example of the "Great American Medicine Shows"—shows that were "bringing new ideas, primitive healthcare, curiosities and relief from the drudgery of daily life to the masses," Keating wrote. These shows were popular in the late nineteenth century before the electronic entertainments of radio and television.

B.J. Palmer (1882–1961) was "without a doubt, part of the circus tradition in America," Keating wrote, citing him as a "P.T. Barnum with Science" and a "genius in the art of promotion and salesmanship."

In the early 1920s, Palmer also was on the forefront of radio and developed WOC—the nation's first station to broadcast west of the Mississippi River. The station's roots go back to 1909, when Robert Karlowa, of Karlowa Radio Company, went on the air from Rock Island with a one-hundred-watt radio station.

The new technology caught the attention of Palmer, who called it "the home vaudeville" and saw its potential for promoting chiropractic. He bought the equipment and moved the station to Davenport in 1922.

The call letters—which have been taken to stand for "Wonders of

Chiropractic" or "World of Chiropractic"—were, in fact, assigned arbitrarily by a radio service division of the U.S. Department of Commerce.

The highest point in Davenport was WOC's aerial broadcast tower on top of the Palmer school on Brady Street—three hundred feet above the Mississippi. By October 1922, the station signal had been received in California, Cuba, Maine and Saskatchewan, and by April 1923, the station had been heard as far as Hawaii and South America.

The station occasionally included segments on chiropractic care but usually broadcast the typical general-interest fare of music, news and other segments. In the late '20s, the station used to have live broadcasts from the Palmer mansion at Eighth and Brady Streets. B.J. had a large organ installed in the home at a cost of $75,000.

The mansion was home to B.J. and Mabel Palmer from 1912 until their deaths—Mabel in 1949 and B.J. in 1961. In the late '20s, B.J. also did broadcasts on WOC on his world travels.

WOC continues today as a popular AM news/talk station (based in a different part of the city), and WOC-TV, the first television station in Iowa, began broadcasting in 1949. It became KWQC-TV (the area's NBC affiliate) after the Palmer family split its radio and television holdings in 1986, and its studios are close to the Palmer campus.

Early Motion Picture Projector Developed in Bucktown

A successful business with connections to home movies and Walt Disney got its start in Bucktown.

Alexander F. Victor (1878–1961), a Swedish immigrant, invented the first electric washing machine for the White Lily Company of Davenport.

From a promising career as traveling magician and illusionist "Alexander the Great" to the washing machine inventor, Victor's creativity and ingenuity led to applications for eighty-six patents and the design of more than 150 different models of still and moving picture machines, according to Davenport historian Doug Smith.

By working in the Edison Laboratories at East Orange, New Jersey, and with the help of the Toledo Company machine shop (where he worked for White Lily), Victor had the opportunity to develop his ideas for an amateur motion picture camera and projector. He built his first model and applied

A Brief History of Bucktown

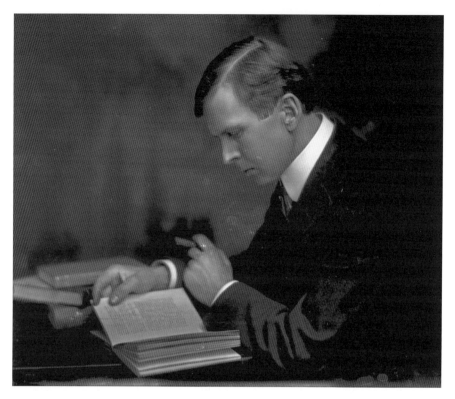

Alexander Victor (1878–1961). *Davenport Public Library.*

for the first three patents: a spiral disc motion picture film, a camera and projector combination and a display machine.

His amateur motion picture camera and projector was also known as the Animatograph, and Victor founded the Victor Animatograph Corporation in Davenport in 1910. It's likely that he exchanged his rights for the washing machine for the capital necessary to develop his motion picture ideas since backers of the White Lily Company invested $100,000 to establish the Victor Animatograph Company on April 1, 1910.

Victor either designed or was instrumental in the development of the moving picture stereotrope, portable electric arc lamp and the 16mm camera and projector, Smith wrote in 2011 for the *Quad-City Times*. "Furthermore, he single-handedly championed the adoption of safety acetate film and various improvements in film size and design, which, above everything else that he accomplished, were crucial to bringing motion pictures to non-theatrical fields."

His efforts spawned the 8mm and Super 8 amateur home-movie industry, Smith says.

Victor started in a small building on Rockingham Road (in western Davenport) and had offices on East Second Street in Bucktown from 1914 to 1918 before moving to 527 West Fourth Street, where the first 16mm projector was developed in 1923. At its peak, Victor Animatograph employed 650 people and in 1946 was located at a plant on Hickory Grove Road.

The world's first 16mm motion picture projector was manufactured by Victor Animatograph and sold to J.H.C. Petersen of Davenport on September 1, 1923.

Victor Animatograph consolidated with the Kalart Company of Plainville, Connecticut, on May 31, 1957, and it became a leader in the field of motion picture technology. Victor died on March 29, 1961, and in 1964 was named posthumously to the Society of Motion Picture Engineers Honor Roll.

Walt Disney (1901–1966) nearly got his start with Victor's company after taking art classes in Chicago at age sixteen.

In a 2006 Bill Wundram column in the *Quad-City Times* that recalled an interview with Disney, the film studio and theme park pioneer said, "Oh, but for the grace of God, I'd still be in Davenport, Iowa, today."

"Walt told how long ago, after graduating from art school in Chicago, he was looking for green pastures. He answered an ad in a trade journal for a cartoonist at a business called Victor Animatograph Corp., Davenport," the column said. Disney explained to Wundram:

> *They needed a cartoonist, and I showed them all my work. I thought it was pretty good. I have kind memories of Davenport. I stayed two days.*
>
> *"After two days the executives called me in. They said I was a nice young man, but that my artwork left much to be desired. They suggested I pursue a career in something beside[s] art. They offered me a job selling movie projectors to schools…*
>
> *It taught me never to be discouraged. If I had given up and stayed in Davenport instead of going to California, I might still be in Davenport today. Just think, had I stayed in Davenport, I might have quit art, and Mickey Mouse would have never been born.*

A Brief History of Bucktown

An Art Deco Cultural Jewel

The Adler Theatre (136 East Third Street) has a colorful history in itself, as a major cultural force in the Bucktown neighborhood.

The 2,400-seat theater began life in 1931 as the RKO Orpheum, part of the Radio-Keith-Orpheum movie theater chain. The vaudeville and movie house chain had owned the Columbia Theater in Davenport (on West Third Street) and needed a larger house. The ten-story Mississippi Hotel formed an L around the new RKO Orpheum on East Third Street. Architect for the $2 million complex was A.S. Graven of Chicago, a well-known theater architect whose buildings included New York's Paramount Theater and Detroit's Fisher Theater.

The 1920 Capitol Theatre—four blocks west on Third Street downtown—was originally in the Orpheum circuit, which operated west of the Mississippi River. RKO was formed after the Keith-Albee-Orpheum chain (east of the

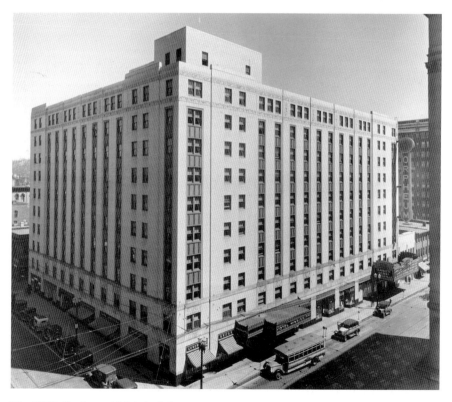

The RKO Orpheum (right), built in 1931, connected to the former Mississippi Hotel. *Davenport Public Library*.

Mississippi) and Joseph Kennedy's Film Booking Office studio were brought together under control of the Radio Corporation of America (RCA) in 1928.

"Nobody else had cash. But Kennedy had a fortune, and radio was booming," says film and media producer Doug Miller of Davenport, who worked at the RKO Orpheum as head usher in the 1960s.

The Columbia was the first Orpheum circuit house in Davenport, and the Orpheum rented the 2,600-seat Capitol Theatre for four years but eventually moved to the larger RKO movie house, which originally had 2,708 seats, built by George Bechtel and sold to RKO.

A special section of the *Davenport Democrat* was published with the Orpheum's grand opening on November 25, 1931, which included an intricate description of its interior design features, such as its gold leaf ceiling, crystal light fixtures and black ebony, walnut and marble details.

"The color of the auditorium is a deep tan, and every detail from seat ends to orchestra rail to chandeliers has been carefully thought out," the newspaper said. "The result is impressive, rich and warm, luxurious yet soothingly comfortable."

When it opened, it was the largest movie house in Iowa, and the Art Deco style—with its "clean, functional, economical design"—was necessitated by the Great Depression, according to a program rededicating the renovated theater.

At the theater's opening, the *Davenport Daily Times* reported of patrons: "Sunk into the luxurious comfort of seats that leave one rested after three hours, they felt a glow of pardonable pride in reflecting that Davenport boasts a theater equal to any in the United States."

"This was the showplace of the Quad-Cities," Miller says, noting it was the largest theater in the state of Iowa at the time and remains so now. The Orpheum succeeded not only as a premier movie house but as a source of live entertainment for the area. Among the entertainers to grace the stage were John Barrymore, Liberace, Ella Fitzgerald, Sonny and Cher, Phyllis Diller and Pearl Bailey, as well as later rock acts like Joe Cocker, Styx, Jackson Browne, the Bellamy Brothers and the Righteous Brothers.

However, shopping mall theaters and other new movie houses with large parking lots ended the Orpheum's reign as a film theater, and its last picture show was *Cleopatra Jones*, shown on September 11, 1973.

RKO sold the building in the late '60s to a partnership among Mel Foster, George Norman and Dudley Priester, Miller says.

Other than touring Broadway productions and and concerts (including Steely Dan, Fleetwood Mac, Journey, Kansas, KISS, REO Speedwagon,

Rush, Cheap Trick, Van Halen and ZZ Top), the theater was dark and deserted for years. In 1981, the (then) Davenport Chamber of Commerce bought the RKO and donated it to the new nonprofit RiverCenter for the Performing Arts, which planned a major theater renovation and convention center project.

After a $4.25 million restoration to its Art Deco glory (including new roof and seats), the renamed Adler Theatre reopened on April 16, 1986 (with 2,400 seats) in a gala concert featuring Burt Bacharach and the Quad City Symphony. As it had been at the orchestra's debut seventy years prior, Wagner's Prelude to "Die Meistersinger" was on the program, which was broadcast live on Iowa Public Television.

The theater was named in honor of E.P. Adler and his son, Phillip D. Adler, former newspaper publishers and leaders of Lee Enterprises, parent company of the *Quad-City Times*. Doug Miller was cochairman of the committee that headed fundraising and first chairman of the Adler advisory board.

A $14 million renovation of the theater was completed in 2006, expanding the depth of the stage and adding a loading dock, dressing rooms and elevators; and improving sound, lighting and rigging. It allowed the theater to bring in larger, touring musicals for its popular "Broadway at the Adler" series.

Besides Broadway productions, performances of the Quad City Symphony Orchestra and Ballet Quad-Cities, the theater has also hosted many concerts and special events.

The ten-story Mississippi Hotel also underwent a major renovation around the time of the last Adler one, with $8.5 million invested in 2007 to create fifty-six new apartments. The Mississippi Lofts take up about half of what was the original 1931 hotel; the other half has been consumed by the enlarging of the Adler.

The adjoining RiverCenter (also connected to the Hotel Blackhawk and Radisson Quad City Plaza, which is on East Second Street) is one of largest meeting/convention facilities in the Quad-Cities and is home to the popular holiday season Festival of Trees, a weeklong fundraiser for Quad City Arts. The center opened in 1983, with two sold-out shows by Milton Berle.

The RiverCenter is designed for meetings, conventions, trade shows, athletic events and other special events and banquets, with 100,000 square feet of flexible space along with two column-free exhibit halls.

The original facility provided about 20,500 square feet of meeting space, including the Mississippi Hall, the Atrium and six breakout rooms. Ten years

The interior of the renovated Adler Theatre. *Adler Theatre.*

later, a feasibility study was conducted and determined that the RiverCenter would be expanded.

The addition of the south building, with forty-nine thousand square feet, was completed in the fall of 1993. A skywalk connected the two buildings, the first skywalk in Davenport's history. The expansion continued with the industrial look and included the Great Hall south, which can be divided in half by operable air walls; four breakout meeting rooms; a board room; and Kaiserslaughtern Square Park. Perry Park Green Space (the lawn on Second Street) was completed in 2002.

A Star's Tragedy at the Adler

Doug Miller was one of the key Davenporters to arrange a special visit of movie star Cary Grant just after Thanksgiving 1986. The dapper eighty-two-year-old English actor was to headline a fundraiser for the first Festival of Trees, a holiday celebration held at the RiverCenter to benefit a visiting artist series (later to merge with the nonprofit Quad City Arts).

Miller was on the original board for the visiting artist series. He and Lois Jecklin (director for Visiting Artists) brought in famed Broadway director

Joshua Logan to the Davenport Club in 1985 and wanted to get an even bigger name for the next year.

They spoke with the National Endowment for the Arts, which suggested Cary Grant, who was always a favorite of Miller, and was touring the country to offer conversations—showing film clips and answering questions from audiences. "We sold him on the idea on this beautiful theater that's been restored, like your movies used to play," Miller says.

Grant flew in on November 28, 1986, and Miller was with him on the private jet from Chicago to Moline. Grant stayed with his wife, Barbara, at the Blackhawk Hotel. Miller was with him the next day for a 4:00 p.m. rehearsal at the Adler Theatre.

Cary Grant (1904–1986). *Moline Dispatch Publishing Company.*

"The reason he did these tours, he wanted to show his wife the America he knew," he said. "Before he was on screen, he was in vaudeville. He traveled the circuit here, before he went to Hollywood. He liked to go to these towns, not the big cities, to show his wife the country he fell in love with. He made many of his films for RKO."

"The fact he was in a RKO theater on the last day of his life is pretty incredible," Miller says.

"One thing that was extraordinary—he didn't like people making a fuss about him," he says. "He didn't have an ego. There were a dozen ushers in the lobby. They were going to man the microphones, for the Q&A, and they break out in applause for him. Grant said, 'I hope I deserve that. Now, let's get to work.'"

As Grant was leaving the stage that day, Jecklin noticed that he asked for support from his wife, she told the *Quad-City Times*. "That was my first indication, but I didn't think anything of it," she said.

When Miller told him he wished him well with the presentation, Grant said "Whatever happens, happens."

"Prophetic or not, he was ready to accept whatever happened on the stage or in life," Miller says. "The courage that he displayed in light of his serious circumstances later that evening was remarkable."

Grant died from a massive stroke at 11:22 p.m. on November 29, 1986, at St. Luke's Hospital (now Genesis Medical Center) in Davenport. The Adler had been a sellout.

Davenport's Infamous District Transformed

While the *Quad-City Times* on November 30 reported Saturday's developments that Grant canceled after falling ill, the December 1, 1986 front page blared, "A Legend Dies in Our Arms." With money from the ticket sales (and a gift from Barbara Grant), Quad City Arts launched the Cary Grant Residency, which has brought in celebrity artists (such as Lauren Bacall, Edward Albee and Colleen Dewhurst) every few years.

Celebrating Music on the River

At one of the most picturesque spots on the Davenport levee, a rock band reigned supreme during the '60s. The Draught House was a nightclub at the foot of Perry Street in a former American Legion building constructed in 1949.

It opened in June 1965, after one of Davenport's worst floods. "There were rats and mice, tables and chairs, everything was floating around there. When the water finally receded, there was a main ballroom, a great big ballroom and a big stage," Rob Dahms, member of the Night People, which regularly played there, told the *Dispatch and Rock Island Argus* in 2014.

Once the venue was cleaned and opened, the Night People performed songs from the Beatles, the Rolling Stones, the Byrds and other groups. More than one thousand people would show up on a Wednesday or Friday night to hear them play and dance. "An article came out in the newspaper saying the Draught House is a den of iniquity," Dahms recalled.

The Draught House "became the place to go for young adults and teens in the late '60s, where the Night People performed, personifying the English movement…in rock 'n roll prevalent in the '60s with heart and exceptional talent," said a *River Cities Reader* editorial in 1993. "Each musician brought his unique personality to the music they performed and made it better for it. In fact, in 1968 the Night People opened for Jimi Hendrix, who played at the Col Ballroom. It doesn't get any better than that."

The Draught House and Night People together "provided a place for young Quad Citians to go, and created a sort of unifying force of young people that reflected the nation's love affair with rock 'n roll, especially during a time of tremendous conflict for young Americans such as the Vietnam War," the paper said.

The Draught House closed in 1971 and was later operated as a variety of restaurants, lastly as the Dock, which closed in 2003 after a fire. The building was demolished in 2015.

Art in the Heart of Downtown

Just two blocks north (and a jog west) of the future Adler, the Davenport Municipal Art Gallery first opened in 1925, on Fifth Street just west of Brady, founded by Charles August Ficke (1850–1931), another prominent German American who represented the ideals and aims of the Forty-Eighters.

A banker and president of the Davenport Turner Society, Ficke served as Scott County attorney and was elected mayor in 1890, with Democratic and Republican party support. With a love of travel, he and his family took extensive tours of Mexico, Germany, Asia and Japan, circling the globe twice. On those trips, Ficke acquired many artistic and cultural items, sometimes buying up to fifty pieces at a time. During one trip to Japan, he sent home thirty-four cases full of antiquities and artwork, the combined weight of which was 7,200 pounds.

Most of these pieces were donated to the Davenport Academy of Natural Sciences (which later became the Putnam Museum). However, Ficke kept all the artwork he bought, beginning with four paintings purchased in Germany in 1894, establishing the foundation of what would become an extensive art collection.

After World War I and Davenport enduring much anti-German sentiment, Ficke grew his art collection by leaps and bounds, owing to his practice of buying several (sometimes more than fifty) paintings on each of his trips out of the country. In May 1919, he donated his collection of rare books to the Davenport Public Library, possibly to make more room for his art.

He donated the rest of his antiquities collections to the Davenport Academy of Natural Sciences to make room for new acquisitions, eventually converting the entire third floor of his house into an art gallery. He felt he had enough paintings to consider establishing a municipal art museum, something he had been considering for years.

By 1924, he had, at the age of seventy-four, outlived all of the other original board members of the Scott County Bank and resigned. That December, Ficke proposed using the Battery "B" Armory building on Fifth Street as a possible site for a public art gallery. If the building was renovated to his requirements, he pledged to donate his art collection to the city.

The city of Davenport asked the Iowa legislature to pass a bill allowing cities operating under special charter (as Davenport does) to establish and maintain public art galleries. The bill passed unanimously, and Davenport soon passed an ordinance creating the Davenport Municipal Art Gallery, the first such gallery in the state. Ficke agreed to give 343 paintings to the city as soon as the building was ready.

Davenport's Infamous District Transformed

An illustration of Charles A. Ficke (1850–1931). *Davenport Public Library.*

Robert E. Harsche, then director of the Chicago Art Institute, examined each painting to evaluate its merit and place in the new collection. He reported that all were high quality and that Ficke's gift was equal to the long-established public galleries of St. Louis, Minneapolis and Los Angeles. He admitted that the collection of landscapes in particular was better than that of his own institute or the Metropolitan Museum in New York.

The Davenport Municipal Art Gallery was one of the first municipal art museums in the nation. During the first three months the gallery was open, nearly fourteen thousand visitors flocked to it. After moving north and west in 1963 (next to the Putnam Museum), the Davenport Museum of Art was part of "Museum Hill" until a much larger modern facility was built on the riverfront back downtown.

The Figge Art Museum, 225 West Second Street. *Figge Art Museum.*

The 115,000-square-foot Figge Art Museum, at 225 West Second Street, back close to Bucktown, was designed by London architect David Chipperfield and opened on August 6, 2005. In recognition of the $13.25 million lead gift to the new building project from the V.O. and Elizabeth Kahl Figge Foundation, the museum was renamed the Figge Art Museum. The capital campaign raised $48.6 million, completing the largest successful nonprofit campaign in the Quad-Cities area.

The Figge has over four thousand works of art, ranging in time periods from the sixteenth century to the present, and is best known for its extensive collection of Haitian, colonial Mexican and midwestern art, particularly pieces by Thomas Hart Benton, Marvin Cone and Grant Wood, including the only self-portrait Wood ever painted. In 1990, Grant Wood's estate, which included his personal effects and various works of art, became the property of the Figge Art Museum through his sister, Nan Wood Graham, the woman portrayed in the iconic painting *American Gothic*.

CHAPTER 5
FROM "KING OF BUCKTOWN" TO ARTS CENTER

Bucktown thrived in part because of the so-called King of Bucktown: James "Brick" Munro (1862–1940), who was well known and loved in Davenport for many years and became known across the country.

A former livery driver (who got his nickname for his shock of red hair), Munro operated Brick's Dance Pavilion and Summer Garden in Bucktown's heyday at Second and Rock Island (later renamed Pershing Avenue) Streets. He also owned seven theaters in the area, a pool hall, a livery stable and the city's first motorized taxi service.

Brick's pavilion was "famous from coast to coast and was a rendezvous for the sporting fraternity from around the United States," the *Rock Island Argus* wrote in 1914, continuing:

> Traveling men would make jumps from 100 to 300 miles just to spend Sunday at Brick's. The place was patronized by men from every walk of life, and there was a steady stream of gold into the till.
>
> Munro spent money with a lavish hand. His big heart proved his undoing. His history reads like a work of fiction—rapid rise to affluence, started in Davenport as a hack driver, bought horse and carriage, owned Family Theater in Davenport and Rock Island, interest in shoe store in the Windsor hotel on Perry Street, had a livery on Third Street, various other ventures, easily worth $150,000.

A Brief History of Bucktown

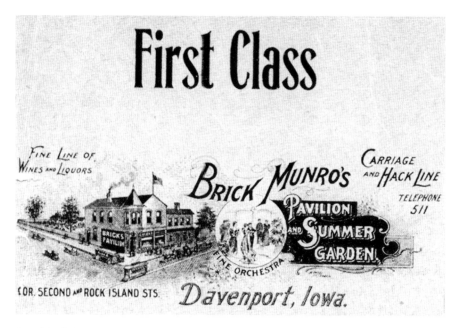

An ad for Brick Munro's famous pavilion. *Davenport Public Library.*

The *Argus* wrote that the pavilion was "one of the brightest spots in the Midwest before Iowa legislators got busy," and it operated twenty-four hours a day (with a saloon, dance parlor and restaurant), employing eight to ten bartenders, ten to twenty entertainers and about twenty-five waiters. Bill "King" Brady, the greatest ragtime piano player in the country, tickled the ivories. The *Argus* recalled:

> Tables were always filled with carefree men and fashionably dressed women. It was no unusual thing for a wealthy spendthrift to buy between $300 and $400 of wine in an evening.
>
> There was something doing every minute. A big orchestra crashed out ragtime strains for the dancers. During intermissions, the cabaret performers took the floor. The patrons were many, they spent without stint.

The *Davenport Democrat*, on October 11, 1955, wrote that Munro "was the good Samaritan of the underworld, the undisputed king of Bucktown." Munro was a poor boy who became one of the richest men in Davenport.

A young singing bartender named Al Jolson entertained at Brick's Pavilion before winning fame as one of the biggest musical stars of the twentieth

century. Despite his saloon's location in Bucktown, with its gambling dens and brothels, Brick Munro did not tolerate prostitutes in his establishment, according to a taped interview with his elder son, James, recounted in a 2006 *Quad-City Times* article.

One of the pavilion entertainers was a piano player named Blind Billy, who appeared on many vaudeville stages across the nation and made much of his claim that though blind, he could play any song called to him from the audience, without music. Billy enjoyed the atmosphere of Munro's and stayed for nearly a year.

The story goes that one day, a bartender called to Munro:

"Hey, Brick, Billy wants to see you."

Munro yelled back: "He'll have a hard time seeing me; he's blind."

Customers in the place laughed, and that became a part of Blind Billy and Brick Munro's nightly routine.

Working Women Add Life to the Place

There was gambling, dancing and drinking at Brick's places, but all the women who worked for him were entertainers or waitresses, even though, in Bucktown, prostitution was accepted as a legalized business. W.J. Purcell wrote in his column, "Them Was the Good Old Days," that Brick's girls danced with customers but that dancing was as far as it went. "I have only good clean girls here," he said. That didn't stop questions from being raised.

The *Rock Island Argus* of December 14, 1903, reported that Brick's was among two resorts "which have led in making the unsavory reputation that has haunted Davenport.…James Munro, who has conducted a saloon and dance hall at Second and Rock Island streets, will be forced to close his dance hall and take out the wine rooms in his saloon," the paper wrote.

"It is probable that the saloon will continue to operate, although under the midnight closing rule which is now being enforced." Munro promised to remove the dance hall and force the removal of the wine rooms.

Floyd Dell, as a socialist muckraker, published thirteen articles in the *Tri-City Workers Magazine* until it ceased publication in 1906, including one focusing on Brick's. The social problems that Dell exposed were those common to any city: inadequate disease control, unsafe working conditions in the factories and poor attendance in the public schools.

Dell wrote his article "Why People Go to Brick Munro's" in the context of Bucktown's flourishing legacy of saloons, brothels and burlesque houses. A 1978 study of Dell suggested that his objections to Brick Munro's formed part of a larger theory of women and society that he would develop later in his career in book reviews, articles and nonfiction works.

"He believed that women were an oppressed class in a capitalist society, and supported their demands for better paying jobs and the vote. He was disgusted by the plight of shop girls and female factory workers whose fourteen-hour days gained them as little as two dollars a week," wrote Marcia Noe in the Western Illinois University regional study.

"In Davenport, these women found their only amusement at dancing pavilions such as Brick Munro's, where men paid admission, but women got in free. Dell regarded this arrangement as legalized prostitution, providing men with cheap female companionship and women with a Half-way House to the red-light district," she wrote.

At Brick's, high-salaried performers from stage plays in Davenport stopped at the pavilion after the last show. There, they took turns entertaining the midnight crowds. It was a relief from the steady grind behind the footlights.

"The money poured into Munro's pockets—but went out almost as fast as it came in," the *Argus* wrote. "Many condemned Munro for the business with which he was identified, but Munro himself was a paradox. He was a tough guy who liked nothing better than to handle his dukes and toss out a roughneck. But at the same time, he was a softie who couldn't let a bum pass without giving him a half-buck," the paper said. "Brick was a pal of the kids."

Frank Ammerman, who was a floor manager at the pavilion, estimated that Munro gave away thousands of dollars worth of free meals alone to unfortunates. At the time of the 1906 San Francisco earthquake, Munro turned over his place to performers to raise money for the victims.

"Stranded theatrical people always came to Munro, knowing he was an easy touch," the *Argus* said. "He was never known to turn down anyone seeking a loan. Often, he veritably gave money away, knowing he would never get it back."

"The Good Samaritan"

A January 16, 1914 article calling Brick the "Good Samaritan of Davenport's Underworld" said that his fortune dwindled from $150,000 to nothing.

Having a "reputation of never turning a deaf ear to the pleas of the needy," he was generous to children in the area.

One article said the People's Union Mission was operating on Second Street, raising funds for a gymnasium, but was unable to make headway. One day, Munro heard about it and immediately sent for the director, asking how much it would be to fit up the gym. When he heard the amount, Brick wrote the director a check.

Munro put up a major share of the funds for what later became Davenport's Friendly House and annually provided it with money to buy Christmas presents for poor children. The *Democrat* wrote: "In his days of prosperity, Mr. Munro was looked upon as the Good Samaritan of the east side. The poor he helped ran well into the hundreds, and not a few persons who died penniless were given decent burials at his expense."

He went into bankruptcy after "the 12-hour law and the vice crusaders closed up the old district and in turn put him out of business," the *Argus* said. The profits stopped when the 10:00 p.m. closing law went into effect, spelling doom to Bucktown by 1909. A reformer filed an injunction against Munro, and that was the end.

After Munro closed the famous pavilion, he became owner of the Hollywood Inn roadhouse, which was targeted by federal agents. It was gutted by a fire on January 11, 1924, in west Davenport, after having been closed the previous summer after being raided by agents.

In his obituary in the *Davenport Daily Times* on October 28, 1940, Brick was noted as having died in poverty. His pavilion "was one of the most famous spots in Davenport," the obituary said.

A Bucktown Rebirth

Sixty-five years after Brick Munro's death, the energy and entertainment of this corner of Bucktown rose again as the four-story brick building there—built in 1910 as the John F. Kelly wholesale grocery business on the site of the former pavilion—was rechristened Bucktown Center for the Arts after a $2.4 million renovation in 2005.

Donna Lee of Rock Island, who worked for a time as manager for the collection of art galleries, studios and shops now at 225 East Second Street, wrote in August 2006 to Richard Munro, Brick's grandson: "I knew Brick's energy was still here and the legacy he left behind needed to be told. That's

A Brief History of Bucktown

The John F. Kelly building, at the site of Brick's pavilion. *Doug Smith.*

about it. It's mostly about a fondness for a man and his family that made history. I just don't want it to die."

She added that "no one speaks more for the soul of Davenport than James 'Brick' Munro. His family, his people were the true soul of this town. They made it flourish as much as anyone."

Bill Hannan, an artist in Moline, Illinois, was on the planning committee for Bucktown Center for the Arts, formed under the umbrella of MidCoast Fine Arts, which launched in 1991 and has a handful of other galleries in the area.

"The thought was, they needed a collective, for a central location," he says. "What came out was a lot of the younger artists, they needed studio space."

After the Bucktown building had been used several years for furniture warehousing, it was empty starting in 2003 when Peterson Hagge Furniture moved out. "Our original concept was all art studios," former MidCoast executive director Dean Schroeder said before its 2005 opening, "but the study indicated that we needed mixed use. The second part of the study researched downtown Davenport properties, finding 14 available buildings that were narrowed to three. The Peterson Hagge Furniture store building came out on top."

MidCoast bought about two-thirds of the building and rented space for galleries and studios on the first two floors, with condominiums, offices and meeting space (including the Midwest Writing Center) on the upper floors.

To relieve the nonprofit from being a landlord and responsible for building maintenance, MidCoast sold its controlling interest in the Bucktown building in August 2015 to developers Y&J Properties, which specializes in rehabilitation of historic buildings in Davenport.

MidCoast's space for local artists has remained open, as it negotiated a ten-year lease with Y&J. The developer owns residential space in the building and planned to redevelop the second and third floors for residential use over eighteen months following the sale.

Y&J Properties has rehabbed or is rehabbing more than two hundred loft units in downtown Davenport, including the Peterson Paper building across from Bucktown. Halligan Coffee Company Lofts, at Fourth and Iowa Streets, was renovated into forty-five loft apartments that opened in the spring of 2015.

Bucktown Center is "an unusual combination of energies where you will find professional artists practicing on site, educational programming,

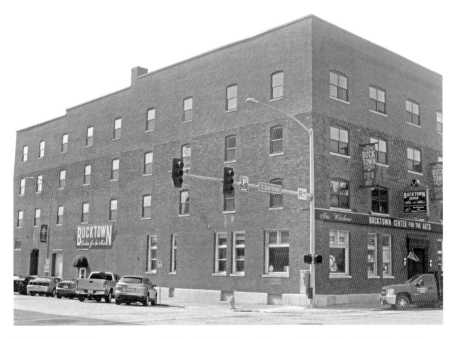

The Kelly building was converted into the Bucktown Center for the Arts. *Author's collection.*

and gallery opportunities with no commission fees for emerging artists," MidCoast executive director Sherry Maurer says.

It has "served as a leading locus for area artists who want to sell their artwork as part of developing professional careers," she says.

"We've had hundreds of artists, both amateur and professional, walk through these doors," MidCoast board president Amy Orr says. "We've seen it all—from painters, sculptors and animators to photographers and jewelry makers—and MidCoast has become a better organization because of it."

Since 2005, it also has helped attract other businesses, residents, visitors and building redevelopment in the Bucktown area. "It's breathing life into the neighborhood again," Orr says.

Pat Bereskin, owner of Bereskin Fine Art Gallery & Studio on Bucktown's first floor, has taught art for years and loved the cooperative nature of the building since she moved there in 2013.

"I thought it gave artists another voice. My mission, while continuing to teach, you want to sell," she says. "What do you want, to end up with a million paintings at home? That wasn't important to all the business partners. We just wanted the space, for that awesome energy with other artists. This was the perfect solution."

"It's like lasagna—everybody brings another layer and it tastes better," she says of the variety of artists. "On top of that, we keep each other in checks and balances, evaluating each other's work. It's multigenerational and diverse. I think we're a pretty unique place."

Heidi Brandt, co-owner of Boho Chic in the building who also works as a real estate photographer, says: "We all do something different. All of our strengths individually, it's a nice smorgasbord mix. We have business people, teachers, bankers, retired Arsenal and Deere. We just, all of our talents really meld together."

"This place, to me, is an arts incubator," she says, noting she's rented space at Bucktown since 2007. "Putting your art up on the wall, you learn so much from people. You get that feedback. Sometimes, a compliment is just as good as a sale. It helps you grow. To be able to meet the artist here, or see the artist work, people love that. Because it's a fascinating process."

The Bucktown Center has helped spark revitalization of downtown, Brandt says.

"With the art and the character this building has, you can't find it anywhere else. We just wouldn't work in a strip mall," she says. "It was a warehouse district, and farther east, there were vacancies. It was a sleepy part of town. With all that development, that perception has gone away."

Many people also want to support local artists, Brandt says. "That's what I do when I travel. You get such a better feel for the area when you visit those local places. And you're helping to support people's livelihoods."

Bill Hannan agrees Bucktown has helped attract other businesses downtown, as did the much larger and flashier Figge Art Museum, located west down Second Street, which also opened in the summer of 2005. With the River Music Experience between them in the historic Redstone building at Second and Main Streets, they have created an arts corridor on the block.

"I think Bucktown has already succeeded in being the pioneer in the east end of downtown," Downtown Davenport Partnership director Kyle Carter says. "Back in 2004, there wasn't anything over there. It was a ghost town. Now, it's one of the most vibrant corridors that we have."

"Regardless of Bucktown's future—failure or success—it has achieved its initial goal, which was to create a home for the artists, serve as an economic development engine for that chunk of downtown that was just absolutely vacant," he says.

Loving Life Living at the Center

Rachael Mullins Steiner was one of the first homeowner converts, as she bought one of the first condos at Bucktown: a two-floor unit that has sweeping views of the Mississippi River and Government Bridge.

She was working for the Davenport schools and living in Moline and wanted to be closer to work. Steiner is also an artist and involved with MidCoast, volunteering for events and grant writing. She purchased the empty space and was responsible for her renovation and construction costs.

Now it is a homey, 2,500-square-foot, one-bedroom condo, with the top floor used as a studio, guest bedroom and storage, which Steiner shares with her husband. Their renovation included installing a wrought-iron spiral staircase taken from a bank building in Walcott, Iowa.

The galleries at Bucktown opened in July 2005 while Steiner's condo was under construction. She also served on the River Music Experience board to help that facility open in a historic building a few blocks down Second Street in June 2004.

"It's interesting, the Figge and Bucktown serve as bookends on Second Street. We're 225 East Second, and they're 225 West Second," Steiner notes. "And so it's really an interesting contrast, in the old and new. This is much

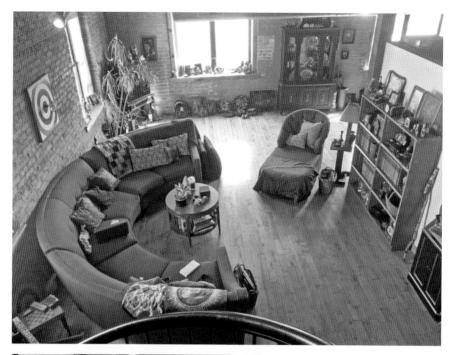

Above: A view of Rachael Mullins Steiner's two-floor condominium. *Author's collection.*

Left: A wall mural in the condo honoring Brick's pavilion. *Author's collection.*

more the grass-roots, creators' model, and that's more of the classic fine arts museum model. That's what keeps the downtown exciting and still attracting not only new people but new uses to the downtown."

"This is a renaissance around housing, and we're still exploring new festivals, new businesses, and we're still seeing developers being interested in the downtown, new models, not just for housing," she says.

"I think it's wonderful there is this sort of infill, that it's not just wipe it all out and start over," Steiner says of the downtown development. "I think it's really smart. And I have to say, our city is really progressive when it comes to the riverfront, flood management, traffic control and festivals and development. They're doing it right downtown, to allow these functions and uses to coexist in this space. Downtowns don't thrive without that. That's been tremendous."

She got her artist friend Terry Rathje to paint a vivid two-story mural on one wall of her unit in tribute to Brick Munro's Summer Garden and Dancing Pavilion on the site. So the spirit of Brick and Bucktown live on, literally, in the heart of Bucktown.

New Life for Neighboring Building

A nearby brick building on East Second Street is thriving with commercial businesses, on the site where John Emerson (former owner of the slave Dred Scott) started to build a home.

The current three-story brick building in Bucktown (with a historical plaque honoring Emerson and Scott) originally housed a Reimers & Fernald candy factory, dating from 1892. The company was an early manufacturer of crackers and candy.

Founded in 1871 by Captain August Reimers, the company became known as Reimers & Fernald in 1874. The business specialized in the Poetless brand of crackers, with a distribution throughout much of the Midwest.

Reimers & Fernald remained in the building through 1909, but in 1910, a washing machine warehouse (Lasher Manufacturing Company) was the occupant. In September 1921, the local architectural firm of Clausen & Kruse designed alterations for the Crane Company, a heating supply distributor that occupied the building for many years.

Mary Talbert (an artist and graphic designer) opened Crafted Quad Cities shop in the former Crane building (217 East Second Street) in January

Above: The Crane Company building, on the John Emerson site. *Author's collection.*

Left: The exterior of Barrel House. *Author's collection.*

2015. It includes a retail shop and working studio, joining a number of other businesses in the building.

The ground-floor space had sat empty for three years, after housing an ad agency. "I love it, because what I am trying to do is related to the arts, and I sell some of the artists at Bucktown," Talbert says. "This street has that urban, quirky feel. It's awesome. The growth of this area has been incredible."

Crafted Quad Cities offers handmade items such as letterpress posters, ceramics, upcycled book journals, quilts, jewelry, photography, pottery, fabric baskets and unique vintage items

The site's Emerson-Scott heritage was cemented in 1986, when the former Davenport Cement Company restored the Crane Building and named the alley behind the building Emerson Place.

Dana Wilkinson, co-owner of Paragon Commercial Interiors (at 210 Emerson Place), moved her business from north Davenport to Bucktown in 1990. Working with Rejuvenate Davenport and the Blandine Club, Paragon restored an 1877 fire station at 117 Perry Street, which is on the National Register.

"In the late '80s and early '90s, nobody was moving into downtown," Wilkinson recalls. "It was pretty dismal. There were just a ton of empty storefronts. We were excited to come downtown. We believe in urban development. We thought it would be exciting to be in an urban area."

"We could see the potential for lots of businesses," and they even withstood the major 1993 Mississippi River flood. With co-owner Darla Evans, Paragon moved to the nearby G.F. Knostman/Mace Chemical building (its current location), which was built around 1860.

Wilkinson and Evans gutted the third floor to create an upscale, modern three-thousand-square-foot work space, maintaining original wood floors and brick walls, with a new elevator and windows offering views of the mighty river and growing city.

It took many more years to find tenants for the first two floors—Barrel House bar and restaurant is on the ground level and Nerdwerx advertising agency on the second floor.

"It's a whole different philosophy to work in an urban environment versus a suburban environment," she says. "It's a different set of values, really. For a long time, we were trying to bring in businesses and what the secret was, was residential....People really do want to live downtown, especially young people who would love to live in Chicago, but don't have the resources or don't have the desire to go to a bigger city; they can get that urban feel right here."

CHAPTER 6
AN EMPIRE OF GOOD SMOKES STARTS HERE

Part of what made Davenport and Bucktown famous across the land was the penchant for a good smoke—in the form of Hickey Brothers Cigar Stores.

The Hickey brothers' empire began with $745 that William and Dennis Hickey saved by selling newspapers on Davenport street corners in the 1890s. At its peak, the family owned 156 stores in sixty-eight cities across nineteen states and employed six hundred people.

You could buy a Hickey Brothers cigar at ritzy places like the Waldorf Astoria Hotel in New York, the Drake Hotel in Chicago, the Hotel Rockwell in New Orleans and the Hotel Nacional de Cuba in Havana—the most elaborate of Cuban hotels, costing nearly $10 million to build in 1930 and featuring more than five hundred luxury rooms.

The brothers opened their first cigar store at 123 East Third Street, in the heart of Bucktown, in 1901, when William Hickey was seventeen years old and Dennis was twelve. From this small beginning, the brothers expanded by acquiring and opening other cigar stores, as well as hotel cigar stands, forming Hickey Brothers Inc.

Their first four stores were all in downtown Davenport—including at 424 Brady Street, in the Kimball Hotel in Bucktown, and on the northwest corner of Third and Brady Streets. Besides cigars and tobacco, they also sold newspapers and periodicals.

"Hickey Brothers Cigar Stores were a national institution for over half a century," says hickeybrothers.com (the reconstituted business that operates

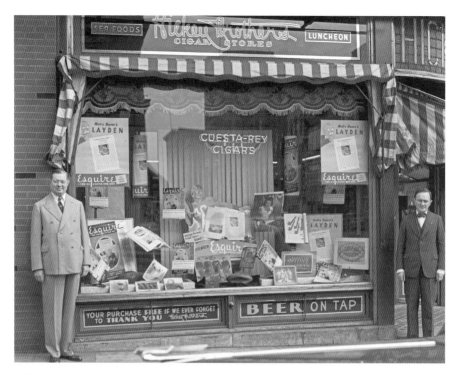

William Hickey (left) and his brother, Dennis, at one of their cigar stores in Davenport in 1920. *Davenport Public Library.*

out of Rock Island). "Much of the success was due to the policies of William Hickey. He started with a unique customer relations policy: 'If Hickey Brothers ever forget to say thank you, your purchase is free.' He insisted upon displaying merchandise attractively and maintaining courteous and efficient service. Because of these policies, most of the finer hotels of the country permitted Hickey Cigar stands in their lobbies."

The finest store in Davenport was No. 8, which the Hickeys opened in 1917. "It lit up the northeast corner of Second and Brady Streets like a movie theater marquee," the Hickey Brothers site says. "It was the principal store in the nationwide Hickey chain, and was more like a club than a cigar store."

There were lunch counters and a commissary in the basement, neon lights for the evening shoppers—even air conditioning, "the first building in Davenport to offer such comfort," according to a Davenport Public Library history. "Bill Hickey took personal interest in the running of No. 8, promising superlative customer service and guaranteeing that if you weren't thanked for your business, your purchase was on the house."

A Brief History of Bucktown

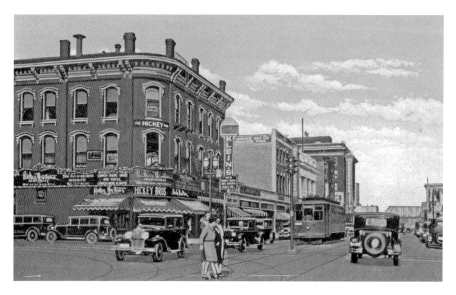

A view of Second Street east from Brady around 1929, with a Hickey Brothers store at left. *Doug Smith.*

"Customers were loyal, too," the library history notes. "The merchandise was varied and of the best quality for the discerning gentleman: cigars, pipes, tobaccos, candies, electric shavers, stationery, cards, and newspapers from around the country."

After being reorganized as one of the nation's top dealers in retail and wholesale tobacco trade, William Hickey served as a director of the Retail Tobacco Dealers of America for fifteen years. After holding the office of vice-president and treasurer, he was elected president of the association in 1949.

By 1951, Hickey Brothers had become the nation's third-largest cigar store company, with 130 stores and annual sales rising like smoke rings from $12,000 in 1901 to $7 million in 1951, according to the website.

On April 14, 1951, Hickey Brothers celebrated a golden jubilee of the nationwide chain with a large banquet for friends and employees, 350 in attendance. William spoke about the last fifty years and "how he hoped the Lord would be good enough to permit him another ten years in the business." Unfortunately, "he was cheated by four years," the history says.

Davenport was shocked with the news on March 19, 1957, that all stores across the country had closed. The pre–World War II business practices that had "sent Hickey Brothers flying high—expansion, buying and employment policies, etc.—were eventually their downfall," the library history says.

William Hickey invested more than $350,000 of his own money in order to keep the company running but was forced to declare bankruptcy and shut down the business that was a dependable backdrop to so many lives in Bucktown.

The store at Perry and Third Streets was known for "their exceptional merchandise—specialty candy, pipes, billfolds, lighters and a wide selection of newspapers," according to Marlys Svendsen. The Blackhawk Hotel lobby had its own Hickey Brothers store. William Hickey died two years after the stores' closure, in 1959, at his home just north of Bucktown at 701 Iowa Street.

In 1997, forty years after its demise, Clinton, Iowa native Michael King revived the Hickey Brothers name when he opened a cigar store and hookah lounge in the same location as the famed store No. 8 in Davenport. In 2000, Hickey Brothers Cigar Store & Hookah Lounge moved to its present location in downtown Rock Island, Illinois, where it continues today to serve aficionados of premium cigars and hookah.

CHAPTER 7

AN ICONIC HOTEL AND OTHER HISTORIC LANDMARKS RESTORED

The oldest and most iconic landmark in Bucktown is arguably the Hotel Blackhawk, which just celebrated its 100th anniversary in 2015 and has a dazzlingly colorful history—from sophisticated glory to dilapidation, bankruptcy, renovations, ruin and abandonment before returning to restored, more opulent, vibrant life again.

At 200 East Third Street, the eleven-story hotel (which did not start so tall) is connected to the north building of the RiverCenter, Davenport's convention center, and across the street from the RiverCenter south building. The hotel is just down the street from the Adler Theatre, which opened sixteen years after the Blackhawk—itself named for the famed Native American warrior.

Before construction of the Blackhawk Hotel, the Saratoga Hotel occupied the land. On February 16, 1915, the first seven floors (225 rooms) of the "New Fireproof Hotel Blackhawk"—the first fireproof building west of the Mississippi—were completed. The hotel was built at a cost of $1 million by Davenport businessman W.F. Miller. By 1921, the remaining stories, eight through eleven, had been added, giving the hotel 400 rooms.

Designed by the Davenport architectural firm of Temple & Burrows, the hotel features Italian Renaissance design along with modern Art Deco.

The building is 140 feet tall, covered in dark-colored bricks that contrast with the white terra cotta. An elevator shaft was added to the east side of the building in a 1978–79 renovation. Originally, the lobby contained a two-story atrium, but it was enclosed in later years to create additional meeting

Davenport's Infamous District Transformed

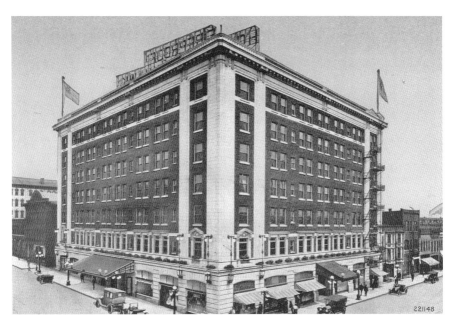

Above: The original Blackhawk Hotel, built in 1915. *Putnam Museum and Science Center.*

Right: The hotel, seen in 1925. *Davenport Public Library.*

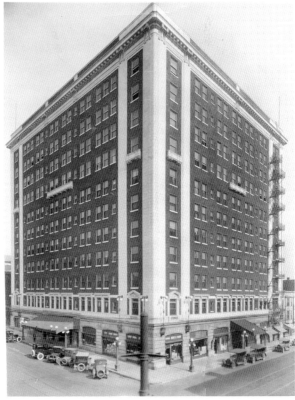

space. The atrium was restored as a part of the 2010 renovation to the building. A new entrance was also added to the east side of the building facing the parking lot.

In 1935, a Junior Ballroom was constructed, and the popular Gold Room was enlarged. A new dining room called the Pompeian Room was opened. Space on the mezzanine level could accommodate one thousand diners. A sidewalk canopy replaced a marquee over the main entrance in 1955.

In 1967, the hotel was sold to George Norman & Company, which, in turn, sold it to the Blackhawk American Corporation two years later for more than $1 million. The hotel was once again renovated in 1969.

Plans to convert the hotel into a three-hundred-unit low-rent facility for the elderly were announced on October 13, 1971, and a petition for foreclosure on the mortgage was filed in Scott County District Court on December 16, 1971. Financing by the Federal Housing Administration to convert the hotel to low-rent housing was delayed in early 1972, and Blackhawk American Corporation announced that the hotel would remain open despite the setbacks.

On January 20, 1972, plans for converting the Blackhawk to elderly housing were dropped. On December 13, 1973, stockholders were told the hotel was bankrupt. A foreclosure lawsuit was filed against the hotel on March 14, 1974. A U.S. marshal's sale of the property on June 28, 1974, failed to produce a buyer, as did an auction in November of the same year. The Small Business Administration, which owned the hotel, considered selling the property for less than the $820,000 it had put into the building.

The Blackhawk was sold to Blackhawk Hotel Associates, a subsidiary of Knightsbridge, for $1.2 million on January 28, 1975. An auction of the hotel's furnishings and accessories was held the following month. In June of that year, phase one of a nearly $1 million renovation was completed. A year later, the Davenport Bank and Trust Company foreclosed on the hotel's $990,000 mortgage.

Judge Max Werling ordered the Blackhawk closed on June 29, 1976. The bank bought the hotel in October of that year at a sheriff's sale for $1 million.

The building sat empty until Phillips Enterprises began a major renovation of the Blackhawk in 1978. The multimillion-dollar project was completed the following year. More than seven thousand people showed up to tour the renovated hotel on September 15, 1979. The Sundance Social Club opened as the hotel's restaurant.

The Blackhawk was part of the "Super Block" development that opened in 1983. It was the first phase of the city's convention center that would

be named the RiverCenter. The hotel would also serve as the convention center's caterer.

John E. Connolly, a Pittsburgh developer, bought the hotel in 1990, and it became a part of his gambling enterprise that included the *President* riverboat casino. The hotel passed to the Isle of Capri Casino in 2000, when it bought the Davenport riverboat gambling operation.

On February 12, 2006, a fire started in a meth lab on the eighth floor. The hotel had been deteriorating steadily since it had been purchased by the Isle of Capri. The City of Davenport took over the property from the Isle of Capri. In October 2008, a development agreement was signed that gave ownership of the property to Restoration St. Louis. The company announced plans for a restoration of over $35 million.

Demolition work began in January 2009 and renovation work started in April of the same year.

A Grand Reopening

After a $46 million renovation by Restoration St. Louis (including a stunning new stained-glass ceiling of the new two-story lobby), the Blackhawk reopened on December 15, 2010, with 130 guest rooms, including 11 suites on the ninth floor and 20 one- and two-bedroom apartments on the top two floors; shops; a restaurant and bar on the main level; and a swimming pool and spa.

On September 22, 2010, the RiverCenter/Adler Theatre, Hotel Blackhawk and the Radisson Quad City Plaza Hotel announced a cooperative marketing agreement, branding themselves the "Quad Cities Event Center." While each remains a separate entity, they advertise and market themselves together. All three entities form one complex that is connected by skywalks and includes a total of 116,700 square feet of space.

The Blackhawk has been host to several high-profile guests over the years, including writer Carl Sandburg, boxer Jack Dempsey and Presidents Herbert Hoover, Richard Nixon and Barack Obama. Big bands, such as Guy Lombardo and Stan Kenton, played at the Blackhawk on many occasions. Actor Cary Grant was staying at the Blackhawk when he died of a massive stroke at age eighty-two on November 29, 1986, before a scheduled appearance at the Adler Theatre.

In early 2015, Restoration St. Louis owners Amy and Amrit Gill spoke of the long process of restoring the hotel to its former glory. Based in

A Brief History of Bucktown

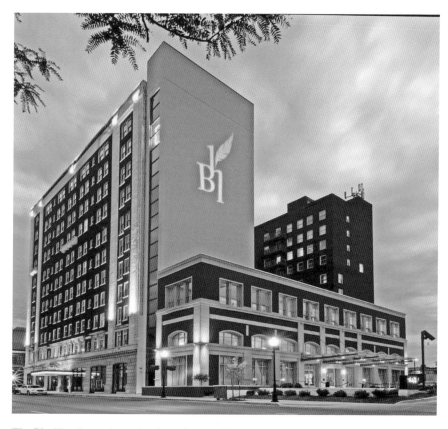

The Blackhawk exterior today, from the east. *Hotel Blackhawk.*

St. Louis, RSL specializes in rehabilitating architecturally significant properties, many on the National Register of Historic Places, such as Hotel Blackhawk—which was its first Davenport project.

In 2006, when Davenport leaders were giving consideration to the redevelopment of Hotel Blackhawk, the Gills were approached by one of their employees, David Hart, whose brother, Thom, was a former Davenport mayor and then Quad City Development Group president. The Gills commented on the Blackhawk project in relation to their work:

> *We must view urban centers/downtowns as "neighborhoods," and what we see happening in downtown Davenport is much more than a collection of rehabbed buildings; it's about (re)building a neighborhood block by block. These "building blocks" are the foundation upon which great cities thrive. When revitalizing neighborhoods, it's about what we term, "urban husbandry."*

Davenport's Infamous District Transformed

> *Each and every building has a story to tell...and given the architectural detail and construction techniques utilized, these buildings represent the hard work of untold architects, craftsmen and laborers. New buildings certainly have their place in the mix of residential and commercial properties, but historic buildings tell the story of this country and its economic development. Historic buildings have the interesting feature of being a repository for the history of a town. They hosted countless marriages and parties; it's where people had businesses and where people remember going as children.*
>
> *The Blackhawk is truly a community icon and is a constant reminder of what can occur when committed individuals rally together to make a difference.*

Davenport is "fortunate to have excellent leadership in both the private and public realms with a focus on urban revitalization and economic growth," the Gills said. "While many other urban cores face stagnation, Davenport has embraced its past as a springboard to its future. The community has a rich stock of historic buildings and a strong desire to see them preserved for the next generation."

The Blackhawk is a member of Historic Hotels of America, a program of the National Trust for Historic Preservation and has been on the National Register of Historic Places since 1983.

A highlight for the hotel was on August 16 and 17, 2011, when President Obama stayed overnight. The president had meals in his room, No. 720, which was renamed the Presidential Suite, even though it's not the most luxurious.

"It's funny, it's one of the smallest rooms in the hotel," former sales manager Lindsay Thul said. "He just happened to stay in that."

When the president was there, the White House booked about 90 percent of the hotel, and the parking lot was blocked off from the public. President Obama loved the hotel's Iowa cinnamon-brine pork chop, later named on the menu as the Presidential Pork Chop.

Extending the Blackhawk Brand

Restoration St. Louis's next major redevelopment is the planned $60 million City Square (underway in 2016) along West Second Street near Main Street in Davenport.

The Parker, Putnam and Center Buildings on Second Street between Main and Brady are being transformed into the City Square development. City Square will include a hotel, office space, retail storefronts and luxury apartments. The Putnam Building will house a boutique hotel with luxury residential units on the top floors. The building is planned to have a bistro and lobby on the ground floor and a Sky Bar on the top.

The Parker Building is now home to Wells Fargo and will house additional office space and residential units. This Second Street block was envisioned by famed Chicago architect Daniel Burnham to have a cohesive appearance, but only the Putnam Building was personally designed by him; construction was completed in 1910. The Parker Building was designed by a successor firm and completed in 1922.

The Putnam will house Blackhawk Suites, a sixty-one-suite hotel with luxury residential units on the seventh and eighth floors. The building also will have a bistro and lobby on the ground floor and a Sky Bar on the top.

City Square will include market-rate housing, retail and office space for the Parker at 104 West Second Street, the Center Building at 112 West Second Street and the Putnam at 128 West Second Street—all technically west of Bucktown.

The addition of hotel rooms will address "existing capacity issues—and will allow for expansion in a growing market via a proven entity," the Gills said. "It will give more hotel diversity to the downtown market as they will not be exactly the same."

Other Restoration Projects Resurrect Historic Buildings

RSL also has completed other historic restorations in downtown.

THE FORREST BLOCK BUILDING, 401 Brady Street, was completed in 2011. The $3.5 million rehabilitation project resurrected a nationally significant historic building. It was constructed in 1875 and is historically important in two ways. It was the first to include a number of stores in one building in a "mall" style, a century before the concept was in use nationwide. Among its other uses, the Forrest Block served as the original location of the Davenport YMCA.

Secondly, it was a building that embraced the new Italianate design style that followed the Civil War and made use of the latest (for the time) eastern

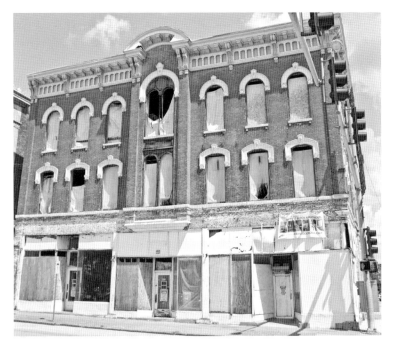

The boarded-up Forrest Block building before its restoration. *Dave Darby*.

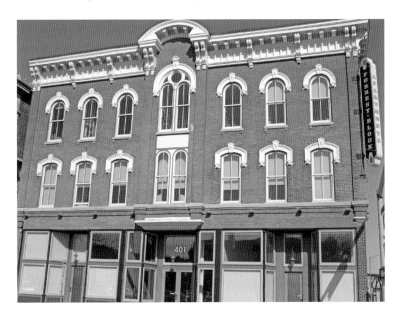

The Forrest Block now. *Author's collection*.

A Brief History of Bucktown

The Renwick Building on Brady Street. *Author's collection.*

building adornments of elaborate cast iron and tin, according to RSL. The Forrest Block houses twenty-four loft-style apartments. It had been vacant since 1980 and eluded demolition in 1991.

In 2012, RSL finished a $4.5 million renovation of the Renwick Building at 324 Brady Street, a structure built in 1897 by famed Davenport industrialist William Renwick. The former Matthews Office and Furniture Store building now houses eighteen apartments. In the fall of 2015, the ten-thousand-square-foot ground floor became home to Daytrotter, an internationally known recording studio, concert promoter and online music catalogue founded in 2006 in downtown Rock Island. The larger Renwick venue also includes a Daytrotter performance space.

The restoration of Market Lofts, 427 Pershing Avenue, down the street from the Hotel Blackhawk, was completed in January 2015. Built in 1905 as the home of Smith Brothers & Burdick Company, the four-story building has thirty-seven loft-style apartments. The $7.5 million renovation preserved

the building's exposed brick and heavy timber beams while incorporating contemporary finishes and modern amenities.

A New Partnership Takes Form

In 2015, RSL announced another partnership to renovate the ten-story Kahl Educational Center, which houses Scott Community College (SCC) programs and the Capitol Theatre, five blocks west of Hotel Blackhawk, on West Third Street. The 1920 Capitol has been vacant since June 2010.

As part of a $50 million project, RSL planned to create a downtown campus for Scott Community College, including revitalizing three buildings—the Kahl building at Third and Ripley Streets and the former First Midwest and First Federal Banks, off Third between Main and Brady Streets, which will become the new downtown campus.

The Kahl building will be renovated into eighty apartments, with ground-floor retail space and the restored theater. The three buildings will be co-owned by Eastern Iowa Community College District (EICC) and Restoration St. Louis.

The two adjacent empty bank buildings will be renovated into an eighty-thousand-square-foot campus with classrooms, computer labs, a science lab, student commons, outdoor plaza, meeting space and administrative offices.

The 1,500-seat Capitol first opened as a movie house and hosted over eighty concerts, films, ballet, other live entertainment and big-screen sporting events from early 2008 to mid-2010, when it closed.

EICC is no longer working with RSL on the project. As of July 2016, that developer has yet to be determined.

CHAPTER 8

ENDURING WORLD WARS AND THE DEPRESSION

Like most of America, Davenport was dramatically affected by the period from World War I to the close of World War II, experiencing exhilarating highs and devastating lows.

During World War I (which began in 1914), one out of every five workers in the Tri-Cities worked at the U.S. Army's Rock Island Arsenal, which employed about fourteen thousand people by 1918. Workers produced many items for American forces in Europe, including harness sets, saddles, gun carriages, recoil mechanisms, two-wheel carts and Springfield rifles.

The arsenal—still today one of the largest area employers—is located on a 946-acre island on the Mississippi between Davenport and Rock Island and Moline, Illinois. The United States acquired the island in 1804 through a treaty with the Sauk and Mesquakie tribes. In 1809, it was established as a federal military reservation by Congress, and another act of Congress established the Rock Island Arsenal in 1862.

During World War I, anti-German sentiment swept through Davenport, affecting its many prominent German American citizens. Teaching of German in schools was banned; Davenport's German Savings Bank was renamed American Commercial Bank. *Der Demokrat*, the German-language newspaper, stopped publication.

The German language disappeared from schools, churches and other public gatherings, following Iowa governor William Harding's proclamation in 1917 outlawing the use of foreign languages. The Davenport public library's collection of German books, magazines and newspapers was discontinued.

Davenport's Infamous District Transformed

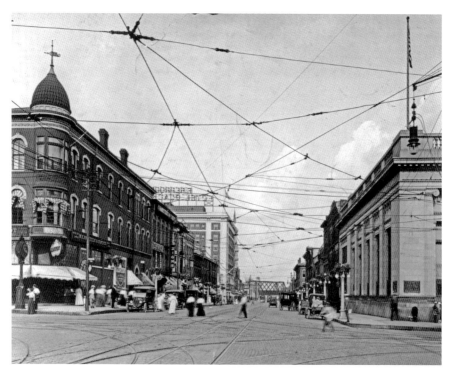

A view looking east on Third Street from Brady in 1917. *Davenport Public Library.*

The Scott County Protection Association even encouraged patriotic residents to splash yellow paint on the doors of all citizens of German heritage.

In Davenport, the Lend-a-Hand Club offered classes for women to become auto mechanics, to bolster the depleted workforce.

On Armistice Day, November 11, 1918, people filled downtown Davenport streets, including one group led by Tri-City Symphony conductor Ludwig Becker, who marched a tin can and washtub band from downtown across the Government Bridge to Rock Island.

At Petersen's department store on Second and Main Streets, a sixty- by one-hundred-foot American flag was draped from the rooftop to nearly street level. Davenport a few months later welcomed back the Iowa Forty-Second Division with a downtown parade.

More than eleven thousand Arsenal workers were left unemployed after the war. Following the war, a Bucktown street was renamed for a famous American war hero, General John Pershing.

In 1919, Rock Island Street was renamed Pershing Avenue at the request of the street's residents, who petitioned the city council for the name change. After the general's visit (in early 1920) was announced on October 30, 1919, residents asked that he be shown the street bearing his name.

His visit was part of a tour of government installations around the country. The announcement prompted Davenport mayor L.J. Dougherty, Rock Island mayor Harry M. Shriver and Moline mayor Charles P. Skinner to send a telegram to the general, urging him to see some of their cities during his inspection of the Rock Island Arsenal.

The triumphant visit by the general who led American forces to victory in World War I included speeches, martial music, a motorcade spanning

General John Pershing (1868–1940). *National Archives photo 111-SC-26646.*

two states and an inspection of the arsenal, making Pershing the first American general to visit the island since the Civil War, according to the *Quad-City Times*.

His tour on January 6, 1920, took him to Pershing Avenue, and from an open car bearing a flag emblazoned with the four gold stars of his rank, he greeted an army of admirers lining the street.

"A light snow that turned into a drizzling rain did not dampen the hearty welcome of a city grateful to the soldier who led the Starry Banner to victory in the World War," the *Davenport Democrat and Leader* reported.

The community—thousands strong—rolled out the red carpet for the railroad foreman's son who led an army that grew to two million after the United States entered the war in 1917.

In Davenport, the official welcoming party included arsenal brass, city officials, a band playing the "General Pershing March" and twenty veterans from Davenport's American Legion post, all of whom had served with him in France.

"Pershing returned the welcome in hearty soldier fashion," the *Democrat* reported. "He was not the austere army chief, but a smiling soldier grateful of his fellow citizens' praise, shaking hands with 'buck' privates before colonels, asking of the health of every service member who wore a wound stripe."

From Boom to Bust

Through the decade of the 1920s, Davenport saw booming business with its hundreds of small shops (selling everything from shoes and cigars to clothes, jewelry and hardware), a handful of major department stores, a growing number of national chain stores and a significant wholesaling trade. The national retailers Montgomery Ward, Sears, Roebuck and Company and JCPenney joined the five- and ten-cent stores in the commercial hub downtown along Second Street.

Wholesale businesses included Halligan (coffee and tea), Crescent Macaroni and Cracker Company, Sieg Iron, Louis Hanssen's Sons (hardware), Van Patten and Sons (groceries) and John F. Kelly (groceries).

The trend of new downtown buildings continued to be vertical. A new skyscraper, the American Commercial and Savings Bank, was built in 1927 and is still today the tallest building in the Quad-Cities at seventeen stories high, if you include the clock tower, totaling 255 feet in height.

American Commercial and Savings tore down a previous bank at the site at Third and Main Streets and erected the current Classical Revival–style building, today housing Wells Fargo and a law firm, as well as apartments on upper floors. The two-story lobby features murals on the ceiling, wrought-iron teller cages, a marble floor and black walnut woodwork.

As a result of the building boom citywide in the '20s, Davenport ranked among the top twenty cities in the nation in growth by 1930.

"The skyline of the city was changing with the construction of office buildings and financial institutions," wrote Mary Schricker Gemberling in a 2015 history of the Hotel Blackhawk.

"Davenport's retail section was the 'Hub of the Tri-Cities' with shoppers from throughout Eastern Iowa patronizing the stores," she wrote. Davenport boasted eighteen movie theaters at the time, and as the city grew, so did the need for added hotel rooms.

In the late '20s, Davenport store owners had a program to attract downtown shoppers. Over many years, they gave out a circular "Davenport Guest" sticker that went inside a car's windshield that allowed shoppers to park an unlimited time downtown and not be ticketed by police. That was before parking meters sprouted.

Three years after the American Commercial building opened in 1928 and two years after the stock market crash, anxious depositors thronged the bank to withdraw their money. Even reserves of this bank, Iowa's largest, couldn't match the demand.

E.P. Adler, publisher of the *Daily Times* (predecessor of the *Quad City Times*), was called on to reorganize the bank. On a November night in 1931, five thousand people packed Davenport's Masonic temple, and he announced his plans, including the returning of cash to despairing depositors.

The view near Government Bridge in 1921. *Doug Smith.*

Adler hired thirty-two-year-old state bank examiner V.O. Figge to run the new bank, Davenport Bank & Trust, which opened in July 1932, and by 1933, it already had more than $12 million in assets. *Time* magazine even wrote of "Davenport's Success Story."

Figge led the Davenport Bank & Trust for sixty years, maintaining it as Iowa's largest and most profitable bank. A six-story addition next door with offices and a parking ramp was opened in 1972.

Vivian Otto Figge—a noted philanthropist—died in 1995 at age ninety-five and didn't live to see the new art museum—opening just a block south of the bank in 2005 with the help of the foundation he established with his wife, Elizabeth Kahl Figge—named for him. In 1994, Figge donated the historic Kahl Building and Capitol Theatre on West Third Street to the Eastern Iowa Community College District.

He also cochaired the $3.5 million fund drive to restore Davenport's Adler Theatre, in 1984 and donated $1 million to an expansion of the Putnam Museum on the hill in west Davenport.

During the Depression, after a similar autumn 1931 run on Union Savings Bank and Trust (at Third and Brady Streets), with lines outside waiting to withdraw, on the day after Christmas 1932, the institution closed "and hundreds of Davenporters lost not only their life savings but also their confidence in America," wrote Marlys Svendsen, in *Davenport: A Pictorial History*.

Much of Union's reserves were linked to farmland, and as the nation's economy crashed, agricultural equipment manufacturers (a backbone in the Tri-Cities) were hit hard as the value of farm commodities plunged and farmers could not afford to buy equipment.

Fifty companies in the Tri-Cities folded in 1933 alone. As several banks closed (in 1933, a moratorium was put on banks across the country, causing them to temporarily close), so did many factories, putting three thousand employees out of work. Thirty-eight suicides, attributed to stress over the economy, were recorded in Scott County in 1932. By that year, the number of people receiving relief in Scott County averaged more than seven thousand a month; staples like beans, potatoes and flour were distributed by the tons.

In addition to companies that closed, others cut back production dramatically. The economy was propped up with a slew of local and federal construction projects.

Davenport public works efforts included construction of the riverfront stadium on the west side in 1931 (today's Modern Woodmen Park),

A Brief History of Bucktown

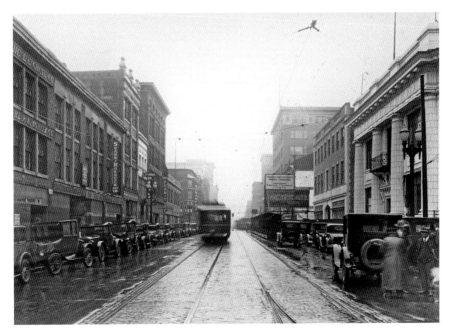

A view of Second Street west from Perry in 1930s. *Davenport Public Library.*

extension of the riverfront seawall and re-laying of 195,000 square yards of brick on city streets.

Construction of Lock and Dam 15 next to the Government Bridge was done between 1931 and 1934 and employed hundreds of ironworkers and masons, as thousands of spectators on the Davenport shore watched the project. The lock and dam was the first of twenty-six such installations by the U.S. Army Corps of Engineers to maintain a nine-foot channel for deep-water navigation on the Mississippi.

The locks opened on August 15, 1933, and then construction of a series of roller dams began. The roller gate design allowed water to pass under rather than over the dam to allow for migration of fish and stabilize water levels above the dams. The lock and dam included eleven gates, and the main and auxiliary locks officially opened to river traffic in the spring of 1934.

"The inauguration of barge service would have tremendous impact, extending to the present, on the Tri-Cities, and completion of the nine-foot channel added impetus to a rebirth of river commerce that would, in succeeding years, see new tonnage records consistently set," reported *Joined by a River: Quad Cities*, a history of the area.

The federal Works Progress Administration projects included a lagoon at Credit Island Park, Davenport, and a new high school in Rock Island. In addition to many park projects, government jobs were created when the new federal building in the Bucktown area was completed in October 1933.

Due to the city's economic boom during the '20s, there was a need for a new post office and federal courthouse. Congress approved $655,000 for the construction on the site of an 1891 building that served the same functions, at 131 East Fourth Street.

Architect Seth Temple—who also designed Hotel Blackhawk—designed the new building. It served as post office and courthouse until 1965 (as the post office moved out), when the U.S. General Services Administration acquired the building, which was later listed on the National Register of Historic Places. It continues today as a federal courthouse.

In the middle of the Depression, Davenport celebrated its 100th anniversary, in 1936. A parade was attended by thousands, and service clubs and churches sponsored dozens of special events to commemorate the city's heritage.

In the '30s, there were excursion boats plying the Mississippi six nights a week "offering dancing couples a jazzy night as vendors hawked liquor after the repeal of Prohibition," William Perry and Bob King wrote in 2010 in the magazine *Films of the Golden Age*. "It was a gay scene with suds flowing freely as the boat plowed moonlit waters and tipsy dancers whirled in happy abandonment."

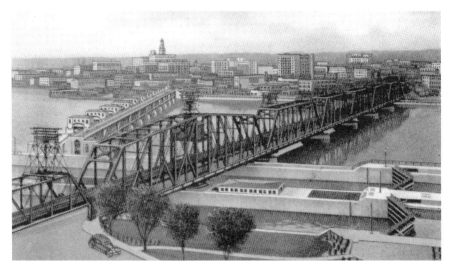

Government Bridge and Roller Dam from the 1930s. *Doug Smith.*

Major nearby bridge projects were completed during the decade, connecting Iowa and Illinois—the Iowa-Illinois Memorial Bridge (first span) in 1935 linked Moline and Bettendorf and the Centennial Bridge in 1940 linked Rock Island and Davenport's west side.

From Peace to War, Again

Before the United States entered World War II, "Everyone was 18 in 1941, and a dozen passenger trains were in and out of the Tri-Cities every day," wrote William Perry in *A Time to Remember*. "Downtowns were hustling."

"We took 1941 for granted in our idyllic time that the wise among us now pontificate was our Golden Age," he wrote.

From Scott and Rock Island Counties, twenty-eight thousand men and women served during World War II. Stores hailed anyone in uniform as a hero. Frank Kapsan and his wife had no children and treated every GI who came to his Davenport Schlegel drugstore (that he managed) as his own. His wife kept a scrapbook of all their service photos.

At the Rock Island Arsenal, employment skyrocketed again, with 18,675 workers producing tanks and artillery for the war effort.

"Rock Island Arsenal along with the rest of American industry recorded war production unsurpassed in the history of the arsenal and the nation," noted a history from the U.S. Army Sustainment Command, which is headquartered on Arsenal Island.

"Entire communities joined together for scrap drives and bond rallies; the renaissance of spirit spread from ordinary Janes and Joes to the biggest of bosses," said Perry. Recognizing the local efforts, *Life* magazine even printed a spread called "How Davenport Sells War Bonds."

In Sturgeon Bay, Wisconsin, on December 8, 1943, the USS *Davenport* was christened, named after the city in recognition of its outstanding war bond sales. It was assigned to the Coast Guard and was among eighty U.S. Navy frigates that would be named after American cities during World War II. The ceremony was broadcast by radio station WOC in Davenport, and a delegation from the city attended, led by Mayor Ed Frick.

During World War II, war bond sales in the city gained national attention because of innovations of the local sales' campaigns, such as Davenport firemen using a ladder to solicit donations from upper-story occupants of the Hotel Davenport.

Davenport's Infamous District Transformed

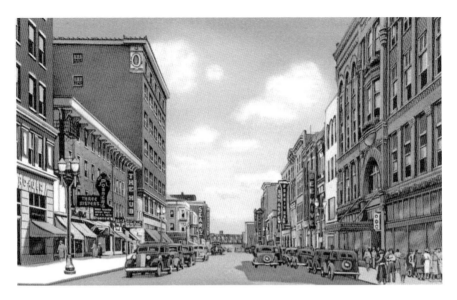

Second Street looking east about 1940. *Doug Smith.*

A Davenport man played a crucial role in the war effort. Robert Lapham commanded a force of nearly thirteen thousand Filipinos. It took three years, until October 1944, for American troops to return to the Philippines. When the country was liberated in 1945, a picture of Lapham ran in newspapers all over the United States.

He returned to Davenport with a hero's parade, and he was just the third American (behind President Franklin Roosevelt and General Douglas MacArthur) to receive the Philippine Legion of Honor.

John O'Donnell, sports editor for the *Democrat and Leader*, gained fame by occasionally beginning his column with a short, homey note to service members addressed "Dear Joe." Starting in 1942, those in the service responded by writing letters to "Dear Joe," and they were printed every Sunday in the paper.

O'Donnell formed a Dear Joe Club, sending membership cards to GIs in thirty countries.

One of the newspaper letters to O'Donnell, from a staff sergeant on August 12, 1945, said: "Your column is a great help in many ways, John. I needn't mention any of them because the boys are telling you every day and the credit you are getting, you really deserve because you are doing so much for us and when someone does something for a G.I., he doesn't forget. It's sure nice to know where your buddies are after you haven't seen them for

A Brief History of Bucktown

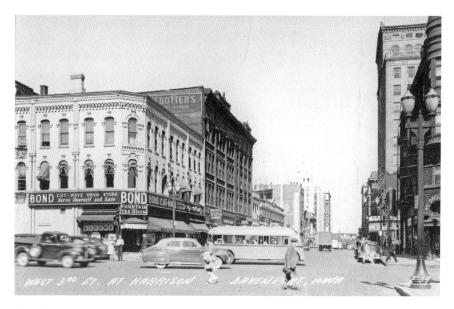

West Third Street looking east in the 1940s. *Davenport Public Library*.

three years or more, and if it weren't for 'Dear Joe,' we still wouldn't know where everyone is."

After the war ended, there was an all-day Dear Joe party at the Mississippi Valley Fairgrounds in Davenport. In gratitude, O'Donnell was given a new Hudson, the first new car he owned. The city's Municipal Stadium, built in 1931, was renamed John O'Donnell Stadium in 1971, shortly after his death. The baseball park, right on the river next to the Centennial Bridge, kept the name until 2007, when its naming rights were sold.

On August 15, 1945, news of Japan's surrender was announced to the world, and Davenport joined with cities across America in rejoicing. The *Democrat* reported crowds gathering downtown within five minutes after the official announcement.

"Soon the business district was jammed with automobiles, and still more came," the paper said in a story headlined "Quad-Cities Let Loose with Untrammeled Joy, and Some Prayers, at Japan's Defeat."

"Thousands lined the streets and cheered cars bearing service men," the paper reported. "Magazines and newspapers were torn to shreds and 'snowed' down from upstairs windows."

"World War II ended with euphoria," Quad-City historian Roald Tweet said in *A Time to Remember*. "By war's end, the cities had become one place—

Davenport's Infamous District Transformed

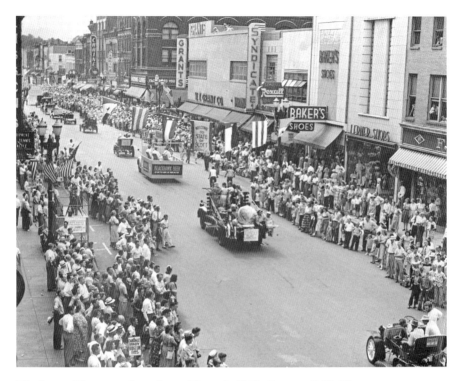

The State of Scott parade on Second Street in 1947. *Davenport Public Library*.

to live, shop, work—one urban community. What had been the Tri-Cities became the Quad-Cities, with Bettendorf among them."

At the end of the war, Davenport had a population of seventy thousand (the largest of the four cities), and the community adopted a motto, "Where the West Begins," borrowed from the signature line of WOC radio.

At the end of the war, a three-year program began through the Davenport Chamber of Commerce to promote the community. Summertime "State of Scott" celebrations were held in 1946, 1947 and 1948, with parades and fireworks. "Beard contests and beauty pageants topped off the festival, which was welcome recreation during the postwar period," according to *Davenport: A Pictorial History*.

By January 1946, Rock Island Arsenal employment had declined to 4,458 and by July 1947 still further to 2,469.

Like most of America, downtown Davenport reveled in flush, good times after the war.

CHAPTER 9

DOWNTOWN UNDERGOES MANY SEISMIC CHANGES

After World War II, the area underwent a rapid transformation, with Davenport doubling its area and adding thousands to its population. "Slot machines whirred merrily in many private clubs in Davenport, where they were an important source of revenue," Jim Arpy wrote in *Joined by a River*.

These started to disappear after the state of Iowa initiated an anti-gambling crusade in 1951, including a law that stipulated that owners who were convicted of providing gambling in their establishments would lose their business licenses. The attitude toward gambling changed drastically less than forty years later, when the state allowed casino gambling if approved by referendum.

"Just as it had a front row seat for the emergence of radio in 1922, the Quad-Cities had an early premiere of the new miracle of communication—television," Arpy wrote. On October 31, 1949, programmed TV launched in Iowa for the first time, as WOC-TV in Davenport aired its initial two-hour program. At the time, there were 1,750 TV sets in all the Quad-Cities.

In *A Time We Remember: Celebrating a Century in Our Quad-Cities*, longtime *Quad-City Times* columnist Bill Wundram wrote of the downtown's golden age in the late '40s and '50s:

> *Downtowns were our excitement, our great white way, our Broadway—the glistening movie marquees on rain-wet streets...*
> *Downtowns were gaudy, wooden-floored dime stores, open until 9:30 on Saturday nights, and 8 to 5 daily—but never on Sunday.*

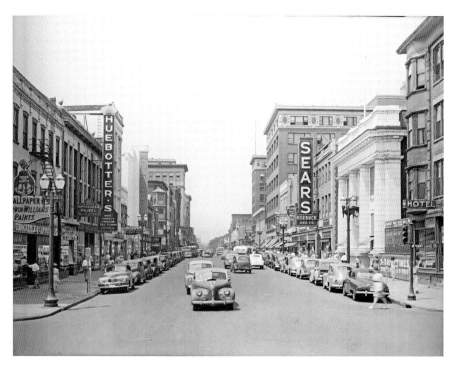

Second Street looking west in the 1940s. *Davenport Public Library.*

"Third Street in Davenport was magic, with six movie houses," Wundram wrote of the RKO Orpheum and Capitol, and the smaller Esquire, the State and Garden and Star. In the 1920s, Davenport had twenty-four movie houses operating, many downtown, such as the Mirror and the Royal, which sat right next to each other.

"Third Street was the place to be, with nearly a half-dozen eateries on every block," he wrote, recalling Brooks 130 Grill and the Louisiana Barbecue, plus Siegel's and Ziffren's pawn shops, Brud's bar and, next to the Orpheum, Leo Kautz's Sportsman's Grill.

"The names of those long-lost downtown stores rattle like the forgotten slams of ghostly cash register drawers," Wundram recalled of the favored Petersen's (at Second and Main), Parker's and Hill's in downtown Davenport. Downtown alone had twelve men's and women's shoe stores, including Baker's and Kinney's.

"It was big-time stuff post–World War II. It was a real bustling area. You could go to shows at the Col, movies at the Capitol or at the Orpheum," says Doug Miller, who worked at the RKO as head usher in the mid-'60s.

A Brief History of Bucktown

Second Street looking east about 1950. *Doug Smith.*

"Downtowns were at their zenith. There was a lot happening. Most of the businesses were locally owned. You had jewelry, leather goods stores, women's clothing stores, a hardware store, and several department stores."

"It reflected a kind of cosmopolitan feeling you would have in a bigger city," Miller says. "The streets were filled; you had such a variety of stores."

Gene Meeker, former head of Rejuvenate Davenport, visited during the '40s and '50s, when he lived in rural Iowa. "It was lively. There were all kinds of stores," he says, fondly recalling the colorful, glittering decorated windows at Christmas at Petersen's. "Now they're gone. It was big days back in the '40s."

Downtown boasted the Woolworth's, Penney's, Sears and Grant's department stores, as well as Walgreens drugstore.

Former Davenport resident Miles Rich (he lived in the area from 1951 to 1980) also recalls downtown as bustling. His grandfather Louis Dockterman owned a car dealership on Third Street on the west side, outside Bucktown.

"We used to walk to lunch. In the '50s, his favorites were Hickey Brothers, at Second and Brady; Johnny Hartmann's, where the Dock was later located; and Fisher's," Rich says. "When Hickey Brothers closed, Shannon's became his favorite. He would often have lunch with his fellow car dealers like George Margulies, who owned Blackhawk Chevrolet; [and] Austin Boeker;

Davenport's Infamous District Transformed

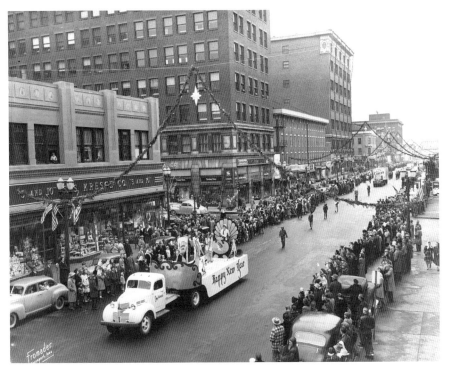

A Christmas parade on Second Street in the 1950s. *Davenport Public Library*.

Third Street looking west from Pershing Avenue circa 1951. *Doug Smith*.

as well as Edward Hackner, who was a large tire dealer; Sam Siegel from Samuel's Jewelers and his brother, Ben; [and] Franklin Alter, from Harry Alter and Sons."

"We often went to the RKO Orpheum for movies, and I saw *The Music Man* there, with Robert Preston when it was on its national tour," he says of the stage version.

In 1950 alone, on the north side of Second Street in the east end were Grant's department store, Robinson's Women's Apparel, Syndicate Hub Men's Clothing, Schlegel Drug Store No. 1, Baker's Shoe Store, Lerner's Women's Clothing Shop, F.W. Woolworth Variety Store and the S.S. Kresge Company five-cent to one-dollar store.

On the other side of the same street were Hills Dry Goods Department Store, T. Richter's Sons Furs and Men's Clothing, Ralph H. Miller's Women's Clothing, Louis Hanssen's Sons Hardware, Mangel's of Iowa Women's Furnishings, Lober's Shoe Store, Cotton Shop Dresses, Federal Bake Shop, Fannie May Candy Shop and Howard's Jewelers.

Oscar Mayer, Ralston Purina and other companies built plants in west Davenport close to downtown. By 1959, more than one thousand homes a year were being constructed. The interstates (80 and 74) opened in Davenport in the 1960s.

The gradual decline of downtown retail and other business also began in the '60s, Miles Rich remembers.

"Parker's died in the mid-'60s. Hills closed in '60 or '61," he says of the old department stores. His grandfather's car dealership moved north

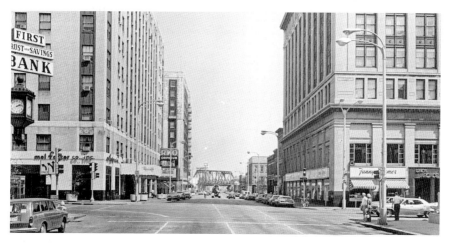

The 100 block of Third Street looking east in 1978. *Davenport Public Library*.

in Davenport in 1970 and was the last new car dealer to leave downtown. Many other stores closed in the '70s, Rich says.

Most of what was left then were banks, Petersen's department store, the Hotel Blackhawk, a few restaurants and office buildings like Iowa-Illinois Gas & Electric (later MidAmerican Energy) and Lee Enterprises, which owned the *Quad-City Times*, though it later would build a new facility on the east end of downtown.

Montgomery Ward and Grant's closed several stores nationwide, including the one in Davenport, and Sears and JCPenney's left for the new NorthPark Mall, which opened on July 11, 1973. With an addition completed in 1982, it became the largest shopping center in Iowa.

Petersen's—in the 1892 Redstone building—in 1928 merged with Harned and Von Maur, becoming Petersen–Harned–Von Maur. Its store in downtown Davenport closed in 1986, as the company (since 1989 known as Von Maur) shifted its focus to malls. It also closed a warehouse downtown, and in 1990, its corporate headquarters moved from downtown to its current location in north Davenport, closer to I-80.

Woolworth's would remain in downtown Davenport until its closing in 1988.

Farm Crisis Deals Another Blow to Economy

A struggling downtown suffered another major blow in the early '80s when Davenport and all of Iowa suffered from a major agricultural crisis.

In 1980, Davenport reached its peak population of 103,264, a total that has not been matched since. "Suburban sprawl and globalization of manufacturing were already significant challenges when the 1980s farm crisis hit," wrote Pam Miner (then the city's director of community planning and economic development), in a 2012 *Public Management* article.

As home to John Deere, the Quad-Cities had long been known as the "farm equipment capital of the world," but Davenport saw thousands lose jobs when Caterpillar, International Harvester and Case closed manufacturing plants in the area and Deere and others temporarily shut down plants and slashed workforces.

In the '80s, "American farmers confronted an economic crisis more severe than any since the Great Depression. Agricultural communities throughout the Midwest and across the nation were devastated," reported an Iowa Public Television documentary.

The crisis resulted from decades of farmers' debt, land and commodity price booms and busts and two droughts in the '80s. "Iowa was the epicenter of disastrous events that brought generations of farmers to their knees," IPTV said.

By the end of 1984, the jobless rate for the Quad-Cities was 10.6 percent, more than three points above the national rate. Hard times in farm and construction equipment caused manufacturing jobs in the area to drop to thirty-six thousand from fifty thousand in 1979.

Low commodity prices made farmers lose money and stop buying equipment, and the era's high interest rates created another obstacle to purchasing, hurting downtown Davenport's economy.

Population declined 7.7 percent during the 1980s, with the loss most evident downtown, Pam Miner wrote. Many traditional department stores and professional offices closed when residents moved away from the downtown.

"Similar to what can happen to older communities, the downtown began to resemble an abandoned movie set, with beautiful old façades but no life behind the window panes," she wrote.

"Although not nearly as severe as the Great Depression, the recession of the 1980s wreaked havoc on the Quad-Cities," the Hotel Blackhawk history says.

"We suffered a lot because of the farm crisis," Gene Meeker (who has also served on the city council) says. "The whole Quad-Cities lost population. It hurt us real bad."

Businesses in the Bucktown area that were later torn down on Third Street east to Perry include the Sportsman Lounge, Ziffren's Loan Company, Louisiana Barbeque, Siegel's Loan Company, Brud's Tavern and the Coin & Stamp Shop. North on Perry from Third Street were the Windsor Hotel, Ada Gaffney Schaff Modeling School and Hertz and Chet's Barber Shop. All of these were torn down by the early '80s for the RiverCenter development.

The City Makes Moves to Rejuvenate Downtown

The new meeting and convention center in the middle of old Bucktown was planned in the late '70s to revitalize downtown's property values and retail sector and attract more tourists and conventions.

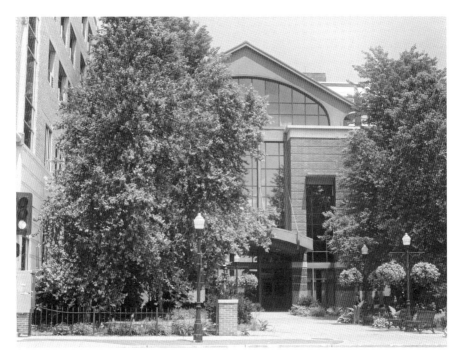

A portion of the RiverCenter. *Author's collection.*

A local hotel-motel tax was approved by voters in the early '80s, and a site was chosen between the Hotel Blackhawk and the Orpheum. With those existing facilities, the project became known was "Super Block," and part of Perry Street was made available for construction of an arched glass entrance pavilion. Construction work began in 1982.

Visiting Artists Inc. raised money to place artwork inside and outside the new center. Artist Sol Lewitt was commissioned for the project, and his work consisted of a concrete obelisk divided into three cubes with geometric shapes incorporated into the surface. The center opened in 1983, including this work, which over twenty years later was moved to the plaza at the Figge Art Museum.

In the fall of 1983, Milton Berle did two sold-out shows at the opening of the RiverCenter at 136 East Third Street, which has hosted major trade shows, concerts, conventions, workshops, festivals and banquets. The first Festival of Trees was hosted there in 1986, at first as a fundraiser for Visiting Artists. When Visiting Artists merged with Quad City Arts Council (later shortened to Quad City Arts) in 1988, the Festival of Trees

was kept on as the major fundraiser for that nonprofit, which also has an annual visiting artist series.

Festival of Trees spans ten days before and after Thanksgiving and uses the entire RiverCenter, with events at other Quad-City locations. There are designer trees, wreathes and room vignettes; multiple special events; and the largest helium-balloon parade in the Midwest (in downtown). The event attracts more than 100,000 visitors annually.

In the mid-'80s, during the worst of the farm crisis, the RiverCenter construction and Adler Theatre renovation projects were able to happen because of a good deal of public funding, Meeker says. "The RiverCenter was all public money, to try and rejuvenate downtown, get convention business."

"I kept saying to people, this is your largest tax base," he recalled saying of downtown. "I gave speeches to different groups, telling them, you may not go downtown, but you still have a stake in its revitalization." Generating more property taxes downtown spreads out tax base across the city.

The convention center and theater are owned by the City of Davenport and have been operated by VenuWorks of Ames, Iowa, since 1998.

The 1993 expansion of the RiverCenter was paid for in part by contributions from riverboat gaming, which came to the area in 1991. The Perry Park Green Space was completed on the south side of the building along East Second Street in 2002.

The RiverCenter South Plaza site was previously home to the Senate Steak House (the original Brud's) and is next to the Union Arcade on Third Street. Moving east from there was Bawden Printing and Advertising, Paul's Pool Hall and Chet's Bar on the corner of Third and Perry.

In 1989, casino gaming was legalized in eight Iowa counties, including Scott, and the first riverboat casinos opened for business in 1991, including downtown Davenport and Bettendorf.

April 1, 1991, marked the debut of riverboat gambling in the United States, as the floating casinos—the *President* in Davenport and *Diamond Lady* in Bettendorf—set off on the mighty Mississippi. The Davenport festivities included fireworks, horse-drawn carriages, marching bands, balloon launches, Mark Twain impersonators and "more hoopla than the Quad-Cities has seen in ages," the *Quad-City Times* said.

The chairman of the Iowa Racing and Gaming Commission then said the gambling license "may be as important to Davenport as the Bill of Rights and the Magna Carta."

The state required each gambling license-holder to be a nonprofit organization that gives out grants, and its sole revenue is a portion of the

casino earnings. The *President* operated in Davenport until October 2000, at the river between Main and Brady Streets. It then was sold and replaced by the Rhythm City Casino.

That downtown casino is being replaced by a new $110 million Rhythm City Casino Resort in northeast Davenport. The Quad-Cities has three casinos altogether.

"There was a lot of anticipation when the boat came in, but it didn't take too long to find out there was not a big increase in business downtown," Meeker says of Davenport. "[Customers] came to gamble and left. There was some disappointment there wasn't a lot of business activity downtown as a result of that."

Demolitions Make Way for New Buildings

Because of the deterioration of downtown, Rejuvenate Davenport formed in 1987 to buy and sell buildings in need of redevelopment or demolition. The organization raised money from public and private sources, says Meeker, who moved to Davenport in 1993, and headed both Rejuvenate and the Downtown Davenport Development Corporation—predecessors of the current Downtown Davenport Partnership.

An example of demolition and redevelopment was the site of an old polluted foundry, long vacant and demolished for the new *Quad-City Times* facility (at 200 East Third Street), built in 1993. "It was terribly run down," Meeker says of the area before redevelopment. "Rejuvenate went in and tore the property down."

In the early '90s, downtown was in a bad state, he says:

> *It was terrible. There were a lot of buildings that were totally vacant. There was no investment, no new capital coming in. That's when we stepped in, when nobody else would do it or could do it. Rejuvenate stepped in, and we would buy these properties. Some we kept; most of them we tore down. Some were too far gone; we had to demolish. Some we were able to revitalize and resell.*

Funding was supported by the expansion of a special taxing district downtown, where property owners pay an additional tax to make improvements within the district. The original district (from the '70s)

extended from River Drive to Fifth Street and Pershing Avenue west to Ripley Street. The district doubled in size, extending east and west and increased the tax amount for the existing sixty-eight commercial properties.

In addition to demolitions for the RiverCenter, a decrepit parking garage was torn down in the '90s for Hotel Blackhawk ground-level parking. The vacant Ward's and old parking ramp were torn down along Second Street to make way for construction of a new Radisson hotel, as was a parking garage with a connected office building for MidAmerican Energy. Rejuvenate was in charge of demolishing those buildings.

A former Bishop's Buffet, Matthews Office Equipment, the old *Quad-City Times* building and headquarters for Lee Enterprises (owner of the *Times* and many daily and weekly papers nationwide) were torn down on the north side of Second for the new MidAmerican Energy building, opening in 1995 at 106 East Second Street. The nine-story office building stands on top of a six-story parking ramp, with ground-floor retail. It stands 220 feet, the second-tallest building in the city after the Wells Fargo Bank building.

Across the street, the Radisson Quad City Plaza, at 111 East Second Street, also opened in 1995. The 223-room hotel—with an open six-story lobby—is connected by skywalk to the RiverCenter, the Adler and the parking garage. The former six-story Iowa-Illinois Gas & Electric (precursor of MidAmerican) building was demolished at Second and Perry.

In 2001, after the state of Iowa launched a grant program ("Vision Iowa") to improve public attractions, a River Renaissance redevelopment was started in Davenport, with city and private partners joining to assemble more than $100 million in public and private investment.

The city built new parking ramps downtown in 2003, totaling more than one thousand spaces, which led to the first new office buildings constructed downtown in more than two decades. The city also backed a $14.5 million public-private renovation of the historic, city-owned riverfront stadium, home to the River Bandits minor-league baseball team.

Rejuvenate bought the vacant Petersen Von Maur building (today's RME), at Second and Main, and its storage building (where a parking garage is now) at River Drive and Main. A partnership of two developers bought the historic Redstone building and renovated it, with offices on the top floor, and the nonprofit River Music Experience opened in 2004, with restaurant space on the ground floor. The RME operates on three levels (including a basement), and there are two restaurants in the building on street level.

A May 2004 *Chicago Tribune* story on downtown's renaissance opined, "The area is not much changed from its description in a 1999 consultant's

Second Street east today, with a skywalk from the Radisson hotel. *Author's collection.*

report: empty storefronts, vacant historic buildings, and seas of asphalt parking lots. People come and go, but seldom stay." River Renaissance aimed to turn that around.

In the fall of 2001, Scott County voters approved a $5 million bond that enabled Davenport to get a $20 million state grant.

Rejuvenate helped tear down buildings on RME's east side for a courtyard and one end of a 575-foot-long, $7 million skybridge over River Drive that opened in 2005, paid in part from state grants.

Just west of RME, Rejuvenate bought and demolished old retail buildings along Second Street for the $48 million Figge Art Museum development. Those were at 209 West Second Street, longtime home of the Del-Rich Pawn Shop and Loan Company, former Sylvia's Women's Clothing Store at 211 West Second and old Hanssen's Hardware building that later housed Rhomberg Furriers.

"For 119 years, Hanssen's was like a downtown Davenport Rock of Gibraltar, until economics forced the company to relocate to the Village Shopping Center in 1970," the November 24, 2001 *Quad-City Times* said. The dazzling new museum opened in August 2005.

Rejuvenate also bought some of the old warehouse buildings in the area that Madison, Wisconsin–based Alexander Company redeveloped.

The eastern half of downtown has developed so much more than the western half since "that's where the buildings were," Meeker says, and the east end was anchored by the Adler and Blackhawk. "We had something to work with. That helps attract investment."

"I think downtown has found its purpose. It's probably the fastest growing area in the Quad-Cities," he says. "Whatever we did, worked. We'll never be the retail center we used to be. That's all gone."

In the past fifteen years, well over $300 million in private investment has helped rejuvenate downtown in the form of dozens of examples of adaptive reuse of buildings, along with many demolitions. The city has again topped the 100,000 population mark and is on track to establish a new population peak in the 2020 census.

CHAPTER 10

RECLAIMING HISTORY FOR NEW LIVING SPACES

Another way Bucktown is special is the fact that city leaders, building owners and developers have promoted adaptive reuse of many historic buildings in the area.

Ohio-based development consultant Pete DiSalvo, who worked on downtown Davenport's strategic plan in 2012, says the Iowa city leads most others of comparable size in downtown redevelopment and that, for its size, Davenport has a higher share of historic properties.

Davenport ranks 284th in population among U.S. cities, but 19th nationwide for total places listed on the National Register of Historic Places (including individual properties and districts).

"The number of historic buildings in any community, registered or not, does not directly correlate to total redevelopment opportunities," DiSalvo says. Many historically significant buildings, such as churches and transit stations, do not lend themselves to conventional adaptive reuses, like for housing and businesses, but downtown Davenport benefits from a rich historic building stock, adaptable for many uses, he says.

That includes former warehouses (many in the Crescent Warehouse District in Bucktown) that readily convert to housing and historic commercial office buildings in the core of downtown, such as the Parker-Putnam and Union Arcade buildings.

The historic designation is key because it provides an owner/developer the opportunity to apply for federal and state historic tax credits (often coupled with other grant and tax incentive programs) to help finance redevelopment in a costly building industry, DiSalvo says.

"Davenport certainly had a history of demolishing historic buildings," he says, noting what's unique about the city is it has done adaptive reuse more than other metro areas. "Davenport is richer for that aspect."

Successful redevelopment creates a snowball effect—"the Crescent warehouse district helped get the ball rolling on that end of town," DiSalvo says of Bucktown. "Just the redevelopment area itself is a catalyst for other developers to want to come in."

Joe Taylor, president/CEO of the Quad Cities Convention & Visitors Bureau, says if it wasn't for redevelopment for many uses, "I fear they would be empty buildings. Instead, they are productive, attractive additions to our community."

Kyle Carter, executive director of the Downtown Davenport Partnership, says many people never would have thought downtown housing would be as hot as it has been. He credits Jim Thomson (CEO of Quad City Community Healthcare and a former John Deere executive) for pioneering downtown apartment rehabilitation in the '90s.

"He was like the first trailblazer downtown in housing, and everybody thought he was absolutely nuts in the late '90s," Carter says.

Thomson (who moved to Davenport from Waterloo in 1986 and started buying downtown buildings) says: "I love seeing old buildings refurbished and brought back to their natural state, as opposed to tearing them down."

He took on a $5.6 million renovation of the former Davenport Hotel, built in 1907 at 324 Main Street, just west of Bucktown. The tenant demographic in the '90s was one-third Palmer College students, one-third elderly and one-third young professionals, Thomson says, noting it's now more young professionals working downtown.

While the former six-story hotel (opened before Hotel Blackhawk) ushered the city into the era of tall buildings, the rehab project completed in 1987 was the first of the recent slew of downtown living projects in the past decade or so.

A November 2007 *Quad-City Times* story said enticing people to go downtown was critical to the health of the core city because the area was no longer a major retail center.

"Another significant factor about the Davenport [Hotel] is that the rehab project occurred at a time when construction of any kind in the Quad-Cities was at a low point," the paper said. "Many of the big manufacturing plants that had buoyed the area's economy for so long were closing, and there was a general economic downturn.

Thomson went on to finance renovations of the Berg apartment building at 246 West Third Street, Executive Square at 400 Main Street and the popular Me & Billy Kitchen & Bar, which opened in 2013 in a one-hundred-year-old building at 200 West Third.

The Henry Berg Building was constructed in 1875, and after several retail uses, it is currently home to Thomson's insurance business, with apartments on the upper floors. The Executive Square building opened in 1905 as the Davenport Commercial Club and was designed by the same architects as the Hotel Blackhawk, Union Savings Bank and Trust at 229 Brady (1924) and the Federal Building at Fourth and Brady (1932–33).

"I just have an interest in it. I think it's fun," Thomson (landlord for over 120 apartments downtown) says of historic properties. "They don't build buildings like that anymore. Those walls at the Davenport are fourteen inches thick, and you never know what you're gonna find. They have character."

Still, around the turn of the millennium, "it was considered absurd that there would be people living in a downtown—let alone seeking to live in a downtown—and that it would be the fastest growing neighborhood in Davenport," Kyle Carter of the Downtown Davenport Partnership (a division of the chamber of commerce) said in a 2014 article in the *Rock Island Argus* and *Moline Dispatch*.

The partnership uses tax dollars generated by properties in downtown to reinvest in the downtown. It focuses on economic development, beautification and marketing and coordinates major summer festivals.

Downtown residential development in the Bucktown area gained traction in 2005 with Crescent Lofts, headed by the Madison, Wisconsin–based Alexander Company, which was recruited and partially paid for by the partnership, he said.

"That was the point where it was official," Carter said. "We were planting the flag and saying 'This is the future,' and began to seek out other developers."

Developers were encouraged to use low-income tax credits, and later, the federal and state historic tax credits, urban revitalization tax exemptions and other programs made the city's urban core more appealing for developers, Carter said.

He said the state-supported River Renaissance project gave the city's downtown a shot in the arm in the early 2000s.

The first "real" out-of-town investment was with Crescent Lofts, at 427 Iowa Street. The Alexander Company—which completed a 1995 renovation of downtown Moline's historic LeClaire Hotel into

apartments—specializes in urban infill and redevelopment and preservation of historically significant buildings.

In 2003, the company set its sights on the Bucktown area, with the goal of riverfront revitalization and renewed economic prosperity for the abandoned Crescent Warehouse District.

The historic Crescent Warehouse District in downtown once anchored the city's thriving industrial trade along the Mississippi River, including several paper manufacturers, a macaroni factory and an ironworks. With the decline of industrialization in the mid- to late twentieth century, many buildings in the district were vacated.

The Crescent Macaroni and Cracker Company building was built in 1915–16. The company got its start in 1875, when three German immigrants established the Davenport Steam Bakery in a building on Fourth Street. As the company grew, it merged with the National Biscuit Company in 1898, and the Crescent Macaroni and Cracker Company was founded.

It was hailed as "the largest macaroni factory in the world" in 1904 and was the only macaroni factory in Iowa at the time, according to the *Daily Times*. The five-story Crescent factory had a shipping center on the first floor, while the others were dedicated to macaroni production, cookie and cracker packaging, dough preparation and baking.

During World War I, the company was a major supplier of food and shipped to seven states, employing two hundred workers. It also produced military rations in the form of corn cakes.

On January 25, 1915, the Crescent Macaroni building on Iowa Street was destroyed in a fire. The building had originally been constructed as the Burtis House Hotel. The company replaced the factory with a new building that was completed within eighteen months.

The Crescent was far from the only distribution and manufacturing company in the area at this time. The Halligan brothers—John, Thomas and Jim—were Irish immigrants who ran three businesses in the warehouse district near the Crescent factory starting in 1907. John Halligan operated a coal manufacturing company, Jim ran Halligan's Funeral Home and Thomas ran Halligan's Coffee Company.

An advertisement from the three brothers read: "Wake up with Thomas Halligan's coffee, keep warm with John Halligan's coal, and be laid to rest by Jim Halligan's funeral home," wrote historian Marlys Svendsen.

The Crescent factory received an update in the 1960s when larger ovens were installed on the fourth floor and spaghetti and macaroni making was discontinued. When these products were discontinued, the company

Davenport's Infamous District Transformed

The first Crescent Macaroni building was originally the Burtis House. *Doug Smith.*

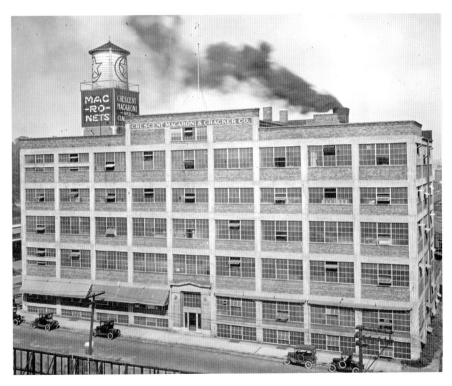

The Crescent Macaroni and Cracker Company in the early 1900s. *Davenport Public Library.*

expanded dough prep, coating, packing and storage in these newly vacant areas. In 1991, the factory sold its baking equipment and closed down, and the building was converted to warehouse use.

The factory sat vacant, as did several of the once thriving businesses in this warehouse district, for many years.

A March 3, 2013 *Quad-City Times* article noted that before the Alexander Company came to the rescue, the warehouse district—bounded by Fourth, Fifth, Iowa and Federal Streets—was "a wasteland of vacant or underused buildings with broken windows."

A "total, total disgrace," as former Davenport alderman Gene Meeker, then executive director of the former Downtown Davenport Development Corporation, recalled.

When Alexander stepped in for redevelopment, the first step was to get the district listed on the National Register of Historic Places, making redevelopment work eligible for federal historic tax credits, a key part of financing. The Crescent factory was converted into fifty-nine loft apartments, called the Davenport Lofts.

Over a ten-year period, the company restored five vacant buildings in the district for 178 units total.

The Davenport Lofts include the neighboring Waterloo Mills building (once a Rock Island Lines freight depot and textile mill) and total seventy-three one- and two-bedroom apartments, with thirty-three different floor plans. More than 70 percent of the apartments are reserved for low- and moderate-income households (part of gaining financing for construction).

The multiphase Alexander transformation of the district (all marketed under the name Crescent Lofts) included:

1) Davenport Lofts: Crescent Macaroni Building, 427 Iowa Street, and Waterloo Mills Building, 505 Iowa Street, seventy-three units; project cost: $12.5 million; completed in 2005.
2) Fourth Street Lofts: Ewert and Richter Warehouse buildings, 320–24 East Fourth Street, fifty-six units; project cost: $10.5 million; completed in 2007.
3) Kerker Lofts: Kerker Building, 315 East Fifth Street, eighteen units; project cost: $3.5 million; completed 2012.
4) Fifth Street Lofts: Sieg Iron Building, 500 Iowa Street, thirty-six units; project cost: $7.5 million; completed 2014.

Davenport's Infamous District Transformed

The Crescent and Halligan buildings today. *Author's collection.*

The Ewert & Richter Express and Storage Company building dates from 1914 and offered "fireproof, safe and sanitary storage." The structure suffered a major fire, however, in February 1933 and was rebuilt.

The Kerker Building was constructed in 1901. By 1902, it was listed in city directories as Kerker Paper Box Company and was owned by George W. Kerker, according to the Davenport Public Library. The building was later used as a coat factory, a clothing factory and (even later) a graphic design business.

By 1901, the Davenport Paper Box Company and the Kerker Paper Box Company were among the first businesses to build new structures in the district. They were followed by the Sieg Iron Company warehouse (1905), a heavy hardware distributor and grocery distributor Smith Brothers and Burdick Company (1905).

The Halligan Coffee Company built a new office and warehouse building in 1907 at the corner of East Fourth and Iowa Streets. The freight building was the sixth building erected in that decade.

The district saw great success in wholesale businesses. After World War II, the Crescent Macaroni and Cracker Company, Halligan Coffee Company, Smith Brothers and Burdick Company, Sieg Company, Marbury Coats

A Brief History of Bucktown

The Halligan Coffee Company building, constructed in 1907. *Doug Smith.*

factory, General Electric Company distributorship, Schlegel Drug Stores wholesale division, Buhrer Brokerage Company food brokers and Frank Lewis Company food brokers were all headquartered in the area.

The last building built in the historic Crescent Warehouse District was an automobile showroom for Vincent J. Neu Oldsmobile in 1950, on the northwest corner of East Fourth and Iowa Streets. It had housed the dealership for nine years when the dealership's rapid growth forced it to move outside the central business district.

The present Government Bridge—which extends over East Fourth and Pershing Avenue—was completed in 1896 on the piers of the 1872 bridge. The first level of the bridge was equipped to carry electric streetcars as well as other modes of transportation, and the upper level continued to carry rail traffic.

As the Rock Island Railroad expanded, Davenport's population also grew—from 35,254 at the turn of the twentieth century to 56,727 in 1920.

Built in 1916, the Fifth Street Lofts building originally was the Sieg Iron Company Building. Over the years, it has served as a warehouse for the storage of lumber and wagon parts and later as a tire-storage facility, according to the *Quad-City Times*.

Davenport's Infamous District Transformed

A Snowball Effect Rolls Through Bucktown

Kyle Carter notes that the Alexander Company and RSL success provided needed confidence in prospects for downtown living and reuse of other historic buildings.

"When Hotel Blackhawk was done in 2010, then Forrest Block got done, and it proved to the rest of developers that market-rate housing was viable in the downtown," he says, "Jim Thomson was the model that if you wanted to take a risk, it could be done. He proved the idea was viable. In 2005, with Alexander Company, it proved that you could use tax credits to rehab huge warehouse buildings and there was a market for it."

Unlike Iowa, Illinois doesn't have a similar tax credit. "That's why we've seen more development over here," Carter says of Davenport. Local urban revitalization tax exemption "has been huge," as well as tax-increment financing, with state and federal historic tax credits to help fund projects, he says.

"The communities aren't losing out, because if you didn't do anything to the buildings, it's not gonna be worth a hill of beans," Carter says, and blighted buildings would sit as vacant, useless eyesores. "With TIF, the city gets that benefit, after the expiration of the TIF, they're gonna get a huge payday off that."

"Were we not providing these incentives, nothing would be getting done," he says.

Before RSL came in to save the Blackhawk back in 2008, "there was a universally held belief in this community that you're wasting your time, you're wasting your money—and they were wrong," Carter says. "We're very proud of that. We fought very hard to make sure they were wrong."

In recent years, the area has seen the following redevelopments for downtown apartments.

Peterson Paper Company Lofts, 301 East Second Street

Completed in late 2012, this five-story gray building (first erected in 1907) became home to nineteen loft apartments, across from Bucktown Center for the Arts.

It originally housed the Davenport Bag & Paper Co., which produced paper bags, wrapping paper and flour sacks. At the time it was constructed, it was touted as a fireproof, reinforced-concrete building.

In 2012, the building's new owner, Manisha Baheti of Moline, and Davenport contractor Joe Erenberger teamed up for the apartment building project. Erenberger has saved several properties in Davenport, including a complete renovation of the historic Bayer Building at 230 West Third Street.

Democrat Lofts, 407–11 Brady Street

Completed in 2014, the former *Democrat* newspaper building (opened in 1924) was converted into twenty-one loft apartments after a $6 million renovation by developers Tim Baldwin and Pat Sherman.

The same architectural firm also designed other historic buildings in Davenport, including the Forrest Block (which is next door to the south), the Hibernia Hall (next door to the north), the Scott County Savings Bank, Davenport Municipal Stadium (now Modern Woodmen Park), the Linograph Company Building and the W.D. Petersen Memorial Music Pavilion in LeClaire Park.

The paper was eventually bought by Lee Enterprises, which published the *Daily Times*. The merged newspapers became the *Times-Democrat*, today's *Quad-City Times* (whose modern headquarters is at the east edge of Bucktown, at 500 East Third Street).

The newspaper sold the old *Democrat* building to the *Catholic Messenger*, the newspaper for the Catholic Diocese of Davenport, and it served as its headquarters for a couple decades. The building also housed a dog training school, a vacuum cleaner salesroom, a dance hall and a specialty store.

Halligan Coffee Lofts, 402 East Fourth Street

Completed in April 2015, the same team that converted the Peterson Paper building—Joe Erenberger and Y&J Properties, owned by Manisha and Manoj Baheti—restored the former Halligan Coffee Company building (at Iowa Street) for forty-five loft apartments.

Halligan started in 1884 when Milton Glaspell and Thomas Halligan founded Glaspell & Halligan, a retail business. In time, it turned exclusively to wholesale trade, specializing in roasting coffee and milling spices. In 1907, the company was reorganized as Halligan Coffee Company, and the five-story brick building that still stands today was completed.

Halligan Coffee distributed coffee, tea, spices and extracts. Thomas Halligan retired in 1918, and other members of the Halligan family joined the company's operations. During the 1920s, the company employed more than fifty-five traveling salesmen.

Union Arcade Apartments, 229 Brady Street

Another imposing downtown landmark in Bucktown—the eight-story Union Arcade office building—was converted into sixty-eight apartments, with ground-floor retail. The $16.6 million renovation was completed in May 2015.

One hundred years earlier, a single-story Union Savings Bank & Trust building was constructed on the site, with the upper stories completed in 1924, in a Classical Revival design by Davenport architects Temple & Burrows.

By the 1960s, the bank building was remodeled to function as the Union Arcade, later with retail and church uses on the ground floor and professional offices on the upper floors.

A 1938 view of East Third Street. *Davenport Public Library.*

A Brief History of Bucktown

East Third Street today, with the Adler Theatre and Hotel Blackhawk at left and Union Arcade at right. *Author's collection.*

Developer Rodney Blackwell of Financial District Properties bought the building in 2012 for $1.6 million. His company has also renovated the historic Wells Fargo Bank building (203 West Third Street) into twenty-nine apartments—on the fifth, ninth, tenth and eleventh floors—and two floors of commercial space, maintaining the ground-floor bank.

With Union Arcade's opening, Kyle Carter said the downtown then had about 1,200 new units and continued the investment in downtown, both commercial and residential. Carter said $52 million in new investment occurred in 2013 and 2014 alone, with over $32 million just in the first four months of 2015.

From 2004 to late 2014, the estimated number of people living downtown nearly doubled, from 1,185 to 2,133 people in that time, using the U.S. Census Bureau's figure of 2.3 persons per household in Davenport.

More Major Projects in the Works

Just up the street from the year-old Market Lofts on Pershing Avenue, another old vacant building is eyed for renewal by realtor John Ruhl, of Ruhl Commercial Company. A six-story building at 511 Pershing Avenue built in 1905 and an attached smaller one built a couple years later are planned to be renovated into sixty-two apartments at a cost of $11.5 million.

The original buildings were used by Crescent Electric Company and General Electric, mainly for warehousing, offices and distribution, Ruhl says, noting he acquired them in 2012.

"This was the last piece of the puzzle for this neighborhood, so we secured it," Ruhl says of the growth in neighborhood housing, and he was attracted to the historic tax credits available for rehabilitation of historic buildings.

Why renovate these decrepit, historic buildings?

"It's a money-making program, an investment," says attorney John Carroll, a partner on the project. "It would cost a lot more to demolish these buildings and build new—prohibitively so. But as can see from what's already transpired down here, it's really a great amenity to the community.

Two vacant buildings at Fifth and Pershing Streets (dating from 1905–07). *Author's collection.*

I went to law school in Omaha, and Omaha has a district called the Old Market District, and it's cool. All the old buildings have been rehabbed. That's kind of what inspired me, doing this with John and other partners."

"This region of east Downtown Davenport is particularly suited for this type of housing. The Crescent Lofts, Sieg Iron Lofts, Crescent Macaroni, and Forrest Block are prime examples of historical warehouses in downtown Davenport that have been successfully renovated as loft apartments," the developers' plan says. "All of which are at full occupancy with waiting lists and demand beyond capacity."

A more ambitious project just east of Bucktown is a plan Joe Erenberger has to renovate nine warehouse buildings off East River Drive at Federal Street at a cost of $30 million. The largest building is the Harborview at 736 Federal Street, which he plans to call the Gordon-Van Tine Lofts.

"I've lived downtown for 16 years," Erenberger told aldermen in January 2015. "What everyone told me they wanted to see, we're finally making that happen."

His plan includes 115 residential units, a movie theater for tenants, a brewery, a grocery store, a solar-heated rooftop pool, a car wash and a doggie wash.

Harborview's largest tenant has been Brown Traffic Products, which is moving to a new location elsewhere in Davenport, he said. The building also contains Isabel Bloom production and other, smaller tenants. Erenberger's plan includes sixty thousand square feet of office space, and he plans to partner again with Y&J Properties.

CHAPTER 11

GATEWAYS TO BUCKTOWN GET NEW ATTENTION

A few properties on the edges of Bucktown have been the subject of intense planning and activity in recent years.

In January 2013, the Scott County Family YMCA bought a signature piece of property on East Fourth Street that later helped brighten and transform the eastern gateway to downtown. The thirteen-acre parcel had been an industrial site for years, formerly owned by W.G. Block, a ready-mix concrete supplier.

The YMCA Early Learning Center, 624 East Fourth Street, opened in June 2015 a child-care facility that replaced the former location at the Davenport Family YMCA.

The Women's Leadership Council, an arm of United Way of the Quad-Cities Area, raised $2.5 million to build the new $2.8 million, eleven-thousand-square-foot center. The facility has a five-thousand-square-foot playground on the east side of the building.

YMCA officials said the child-care venture with the Women's Leadership Council came in response to the council's request for proposals in its effort to improve early learning opportunities for preschool-age children in the Quad-Cities.

Nearby, on the east edge of Bucktown, a hulking former hotel, next to River Drive, was demolished by the end of 2015.

The six-story former Howard Johnson Plaza Hotel (227 LeClaire Street) closed in 2009 and had been a hotel (under several brands) since 1964. On the site, Government Bridge, a new iconic gateway to downtown, is planned.

A long-vacant old hotel at the eastern edge of Bucktown was demolished in 2015. *Author's collection.*

The planned Riverwatch Place. *Ruhl Commercial Company.*

The $25 million development, Riverwatch Place, will be a six-story, mixed-use office building that includes first-floor commercial/retail and restaurant space reminiscent of the former Davenport Club, with river views on the top floor. The building is sixty thousand square feet and will feature outdoor vistas on each floor with a large outdoor dining area.

"The Riverwatch Place proposal is exactly what we were looking for," said Kyle Carter, executive director of the Downtown Davenport Partnership. "Completing this proposal would not only result in the demolition of an eyesore, but it would also mean a major a new construction project that adds to the Davenport skyline and provides a welcoming entrance to a significant downtown gateway."

Improving this site has long been a goal of the developers. "The site offers extraordinary river views and is positioned prominently on the main entry-point to downtown Davenport. Our mission is to deliver a 'trophy' property worthy of the site," said John Ruhl, president of NAI Ruhl Commercial Company.

In 2014, Downtown Davenport Partnership (DDP) loaned funds to Demolition Davenport to purchase the site. Since then, DDP has aided debris removal and asbestos mitigation within the existing building.

Right on the river, at the foot of Perry Street, the long-awaited demolition of the former Dock restaurant at 125 South Perry occurred in October 2015. It had closed in 2003 after it was heavily damaged by fire. There were no immediate development plans for the city-owned site, after the city paid $150,000 for demolition.

Plans fell through in June 2015 for an $11.2 million agreement with developer Todd Raufeisen to build a forty-six-thousand-square-foot restaurant/office space complex. The city might seek plans for another restaurant or maintain the property as green space.

A January 7, 2000 *Dispatch/Argus* restaurant review said of the Dock: "It has a room with a view, no doubt the best view in town. The Davenport restaurant that began as Johnny Hartman's in the '50s and became the Draught House in the late '60s, then the Dock, then the Rusty Pelican, then the Dock again (and maybe some forgotten identities in between) has stood the test of time as a prime destination for dining out."

Building a New Reputation for Food and Drink

Food and drink establishments have helped resurrect the Bucktown neighborhood and make it a busy destination—like it was but in a different way from over one hundred years ago.

Close to Bucktown Center for the Arts is Barrel House 211, which opened in an 1880 building at 211 East Second Street in 2011. The brewpub maintained the 1920s exposed-brick interior and later expanded to more locations in the Quad-Cities.

Its Bucktown home was first used for a furniture manufacturer and later a chemical supply company. The building was vacant for many years before Barrel House gave it new life.

Across the street, closer to the Government Bridge, Great River Brewery, 332 East Second Street, opened in 2009 at the corner of Second and Iowa Streets, which transformed a former Christian coffee shop. For many years before that, it was a muffler shop.

Co-owners Scott Lehnert and Paul Krutzfeldt had owned and operated Old Capitol Brew Works restaurant/bar and brewery in Iowa City until moving the brewery operation to Davenport. They have grown to brew more than twenty different types of beer. Great River in 2014 moved its offices to Iowa Street and into the former Oasis gas station and expanded its tasting room.

Next door, at 318 East Second Street, Artisan Grain Distillery opened in 2015, and values the city's alcohol-drenched history. It renovated a 1916 building that was home to Davenport's first auto dealership, as a Buick company. The building continued to serve the automotive sector through 1940, at which time Schierbrock Motors, Chrysler-Plymouth had their showroom there. Later, a building products company occupied the structure.

It opened as the Wolfer Cadillac Company in 1917. This garage, service station and sales agency was fireproof and constructed so additional stories could be added in the future. When it opened in 1917, it had white tile floors and mahogany furniture throughout. A service and repair shop were also added later on.

Distillers of organic Midwest-grown grains for bourbon, gin, vodka and whiskey, Artisan Grain notes on its website that Davenport was "one of the wettest cities in America."

"It was the age of whiskey for breakfast, where hard grinding workers took a soothing shot before work to stave off aches and pains and enjoyed a slow social drink in the afternoon to unwind from a ten-hour work day,"

Artisan Grain Distillery, in a renovated 1916 building. *Author's collection.*

says artisangraindistillery.com. "The epicenter of this collection of beer halls, wine rooms and saloons was an area called Bucktown. The local newspaper, The *Davenport Democrat*, often referred to the area as a working man's resort. Local clergyman Henry Cosgrove called it 'The Wickedest Place in America.'"

Artisan Grain owner Allen Jarosz said as they unearthed a portion of the building to make way for a new foundation, they found a perfectly preserved whiskey bottle.

In the nineteenth century, there were over a half dozen distilling operations in the Davenport area, the site says, noting there was a very good chance many of the early Illinois settlers depended on Davenport for their whiskey needs.

The modern-day pioneer of Davenport brewing is Front Street Brewery at 208 East River Drive. Founded in 1992, it is the oldest brewpub in the state of Iowa and named for the former moniker of the riverfront thoroughfare.

"Nestled in downtown Davenport in what was originally called the Bucktown area in the 1920's [*sic*], Front Street Brewery radiates the charm that only history can impart," its website says. "Front Street's warm interior is

highlighted by burnished wood and exposed brick walls. The main brewery and restaurant, both more than 100 years old are separated by a quaint brick beer garden." A wholesale grocer occupied the site by at least 1886. Businesses related to whole fruit and grain distribution were commonly located in this portion of the riverfront in the mid- to late nineteenth century and into the twentieth century, according to a study done for the city. The original building on the site was three stories, and the existing structure was estimated to have been built around 1925 and later occupied by a coffee company, among other uses.

Owner Steve Zuidema wanted to start his own business and quit his nineteen-year job at the Cordova nuclear power plant. He and a partner bought an old warehouse, outfitted it and, in a nod to local history, called the new business Front Street.

One of its many beers is called Bucktown Stout, which they describe as "extra dark with a smooth slight coffee." The beer is "brewed with roasted barley and black malts."

Another well-known restaurant in Bucktown (across from the Adler Theatre) is Duck City Bistro, at 115 East Third Street. An upscale bistro since 1991, the building was constructed in 1896 in the commercial Richardsonian style and known as the Schmidt Block because it was built by Fritz T. Schmidt to house wholesale offices for the family's wine and liquor business.

The firm known as "Fritz T. Schmidt and Sons" produced from a west end location known as "Blackhawk Vineyards" that bordered Blackhawk Creek. In the 1980s, the building housed a restaurant called J.K. Frizbee's.

EPILOGUE
BRIGHT FUTURE LINKS PAST TO PRESENT

B ucktown still buzzes (at least in concept), in part from the *Bucktown Revue*, a monthly variety show performed in Davenport since 2008. It not only captures the heart and soul of present-day area talents but also pays homage to the halcyon golden age of America and Bucktown.

Bucktown Revue founder Michael Romkey says the show—in the style of *A Prairie Home Companion*—celebrates "folk culture as it was, and is, here along the banks of the Mississippi River in this part of the Midwest."

"We sometimes tend to think of the Midwest as not having any particular 'flavor' of regional culture, unlike New Orleans, St. Louis or Memphis, which for some reason evoke a definite cultural brand in people's minds, especially when it comes to music," the musician, author and editor says.

"But there has always been an indigenous music scene here, albeit an amalgam of different influences—people like Stephen Foster in early times, fiddle music for Irish social dances at Hibernian Hall, Louis Armstrong and other Dixieland players coming through on riverboats, piping music people brought with them from Scotland, Bix, German polka bands," Romkey says.

The *Bucktown Revue* focuses on acoustic folk music, Irish, bluegrass, Americana, blues, early jazz and standards. When the show moved after a year from Moline to downtown Davenport's River Music Experience, "we thought it would be cool to give the show a folksy name that reflects something about the history and character of the area," Romkey says. "We wanted to evoke a sense of place."

Epilogue

An image from the *Bucktown Revue* (Jonathan Turner at far right). *From* Bucktown Revue.

The RME (at Second and Main Streets, in the historic Redstone building) is in the vicinity of what used to be known as Bucktown, "an area of saloons, gambling parlors and sporting houses, and doubtless a lot of music, so we decided to call it the *Bucktown Revue*," Romkey says.

Because of the show's popularity and burgeoning attendance, it outgrew the RME space after three years and moved up the hill to Davenport's Junior Theatre.

"But we're still all about the local folk music culture, as it once was and has continued to evolve" Romkey says. "The river was the highway through the nation for a lot of years, and it is still intimately connected to all of us here in our daily and creative lives. There's no two ways about it. The Mississippi, the music, the Bucktown of rowdier times—there's a little of all three in our DNA."

It also seems appropriate that the revue—which incorporates skits, monologues, poetry and the occasional barbershop quartet—is at this Davenport property, home to the Annie Wittenmyer Complex, named for the fierce nineteenth-century trailblazer who led the Woman's Christian Temperance Union (which often battled Bucktown's busy saloons).

One of the most glorious nights in Bucktown's recent history was May 14, 2015, when world-renowned cellist Yo-Yo Ma helped the Quad City Symphony Orchestra cap its 100th season.

While the May 29, 1916 debut at the old Burtis Opera House was the only concert in a truncated 1915–16 season, it officially constituted the first season. Acclaimed pianist Andre Watts kicked off the centennial season in October 2014 at the Adler Theatre; brand-new pieces launched every major QCSO program during the year, and Yo-Yo Ma played Dvorak's B-minor cello concerto in a sold-out, one-night-only Adler concert as a bonus to the season.

Another centennial event in Bucktown was celebrated on November 14, 2015, with a swanky complimentary VIP party at Hotel Blackhawk thrown by the owners, including some of the same foods from the very first 1915 dinner at the hotel.

Epilogue

Linking the Past and Present

A new park at the river's edge in Bucktown connects the present to one of the most important periods in Davenport's early history.

A towering figure in American history, Abraham Lincoln now stands literally larger than life as part of a new bronze sculpture dedicated in January 2016 at Bechtel Park, next to the Government Bridge on East Second Street. In 2013, the Bechtel Trusts commissioned Illinois artist Jeff Adams to create a park sculpture reflecting Lincoln's involvement with a lawsuit filed by owners of the Effie Afton steamboat that collided with the Rock Island Railroad Bridge in 1856—the first bridge in the nation to cross the 2,320-mile-long Mississippi.

Bechtel trustee Richard Bittner said the fifteen-foot-high, 3,100-pound sculpture—*Lincoln with Boy on Bridge*—recognizes the historic position that the court case and the Quad-Cities played in elevating Lincoln's legal career, leading to him eventually becoming U.S. president in 1860. Lincoln came to see the original bridge himself as he prepared to defend the railroad and bridge company.

Mr. Bittner said the sculpture—depicting Lincoln and the son of the lead bridge engineer, on a bridge plank, placed upon a pedestal—"will be a constant reminder to all of us of the fact that the perpetuation of our freedom falls squarely on the shoulders of all of us."

At 6:30 a.m. on May 6, 1856, the *Effie Afton*—on its maiden voyage—struck a pillar of the Rock Island bridge, then just east of the current Government Bridge, near Federal Street. The boat caught fire and sank; the bridge was heavily damaged.

A self-taught trial lawyer, Lincoln was asked to be part of the Chicago team that defended the railroad owners against a claim that the bridge hindered river traffic and navigation. According to a history of the case, Lincoln met a boy sitting on the bridge during his trial preparation and asked him if he knew much about the river.

When the boy answered yes, Lincoln reportedly said, "I'm mighty glad I came out here where I can get a little less opinion and more fact," Mr. Bittner related. That quote is on a plaque on the back of the statue's base.

That boy was Bud Brayton, the son of B.B. Brayton, a leading engineer on the project. The 1857 trial, held in Chicago, ended with a hung jury. The judge dismissed the case, resulting in a victory for railroads and bridges across the country.

"More significant is the fact that the bridge was rebuilt, and east–west traffic proceeded to accelerate the free settlement of the West," Mr. Bittner said.

Epilogue

A bronze sculpture of Abraham Lincoln and a boy at Bechtel Park. *Author's collection.*

Epilogue

Creating Another Center for Leisure, Living and Work

Kyle Carter of the Downtown Davenport Partnership wants this part of the city to succeed so much that he put his money where his mouth is.

While he works with businesses and developers to attract new investment downtown, in October 2015, he and business partner Dan Bush opened Analog Arcade Bar in a restored 1918 former bank at 302 Brady Street, across from the Union Arcade building. It features sixty games, from arcade classics to pinball, Skee-Ball and bubble hockey, with a bar that includes one hundred beers.

Originally designed for Scott County Savings Bank by the noted Davenport firm of Clausen & Kruse (architects of the 1923 *Democrat* building), the two-story limestone and granite building had been vacant for over ten years and was last used as a jewelry store. "This is one of the most historic, beautiful buildings downtown," Carter says, noting he was unsuccessful in getting it filled by another business and that they lease the property. "It was hiding in plain sight."

"It's an absolutely gorgeous space," he says. Carter worked with the building owner to expose the intricate tile flooring, convert the two old bank vaults into comfortable lounge areas and fill the interior with the work

A contemporary view of downtown's east side, seen from Rock Island. *Author's collection.*

Epilogue

of local artists and craftspeople. Analog "is one more piece in the puzzle" of revitalizing the Bucktown area, Carter says, pointing with pride to the recently opened Cru wine bar (221 Brady), the Union Arcade, Renwick, Forrest Block and other nearby restorations.

Though the Bucktown of today is radically different from its "wicked" heyday, its persistent, gradual and patiently implemented transformation connects to its red-light reputation (albeit without the brothels).

Both the old and new Bucktown seem determined to provide residents and visitors with a good time, in many more ways than one. From the historic mainstays—the Burtis, Brick's, the Blackhawk, RKO Orpheum, the saloons, gambling parlors and houses of ill repute—to today's examples of the Adler, RiverCenter, Front Street, Great River and Barrel House, making the most of leisure time and one's entertainment dollar appears to be job one.

It is a job that many hardworking civic leaders, developers, business owners and countless others take very seriously. Making fun is a job, and it's one that demands cooperation, vision, dedication, funding and perseverance.

Today's Bucktown still has challenges—its share of vacant buildings awaiting redevelopment or demolition—but its champions, cheerleaders and builders keep at it. The district might not necessarily be wicked anymore, but it's wickedly thriving.

BIBLIOGRAPHY

Biographical Dictionary of Iowa. University of Iowa Press Digital Edition. http://uipress.lib.uiowa.edu/bdi.

Braden, Tammy. "Dr. John Emerson, Fort Armstrong Medical Officer, and His Slave, Dred Scott." bqc.wikispaces.com.

Collins, David, Rich Johnson, Mary Louise Speer and John Willard. *Davenport: Jewel of the Mississippi*. Mount Pleasant, SC: Arcadia Publishing, 2000.

DavenportIowaHistory.com.

Davenport Public Library city directories.

Dell, Floyd. *Moon-Calf*. New York: Alfred A. Knopf, 1920.

Downer, Harry E. *History of Davenport and Scott County, Iowa: Illustrated*. Chicago: S.J. Clarke, 1910.

Downtown Strategic Plan. Davenport, IA: Downtown Davenport Partnership, April 2013.

Gemberling, Mary Schricker. *Hotel Blackhawk: A Century of Elegance*. Moline, IL: Moline Dispatch Publishing Company, 2015.

Hamer, Richard, and Roger Ruthhart. *Citadel of Sin: The John Looney Story*. Moline, IL: Moline Dispatch Publishing Company, 2007.

Hennigan, Peter C. "Property War: Prostitution, Red-Light Districts, and the Transformation of Public Nuisance Law in the Progressive Era." *Yale Journal of Law & the Humanities* 16, no. 1 (2004): 123–98.

Johnson, Rich, Jim Arpy and Gerri Bowers. *Bix: The Davenport Album*. N.p.: Razor Edge Press, 2009.

Joined by a River: Quad Cities. Davenport, IA: Lee Enterprises, 1982.

Keating, Joseph C. *B.J. of Davenport: The Early Years of Chiropractic*. Rock Island, IL: Association for the History of Chiropractic, 1997.

Krist, Gary. *Empire of Sin: A Story of Sex, Jazz, Murder, and the Battle for Modern New Orleans*. New York: Broadway Books, 2015.

May, Christoph. "The Most German City." lewis-genealogy.org/genealogy/History/Schleswig-Holstein.htm.

McDonald, Donald. A *History of the Quad City Symphony Orchestra: Celebrating the Art of Sound for 75 Years*. Davenport, IA: Quad City Symphony Orchestra Association, 1989.

Miner, Pam. "Sustainable Redevelopment in Downtown Davenport." *Public Management Magazine* 94, no. 5 (June 2012).

National Register of Historic Places. Davenport Central Business District. National Park Service. Form 10-900-a. June 1991.

Noe, Marcia. "'A Romantic and Miraculous City' Shapes Three Midwestern Writers." *Western Illinois Regional Studies* 1, no. 2 (Fall 1978): 176–97.

Nollen, John. *Grinnell College*. Iowa City: State Historical Society of Iowa, 1953.

Orpheum Souvenir Booklet, Adler Theatre. April 29, 1982.

Perry, William, and Bob King. *Films of the Golden Age*, no. 61 (Summer 2010).

Pfiffner, John, Martha H. Bowers and Marlys Svendsen. *Davenport: Where the Mississippi Runs West*. Davenport, IA: City of Davenport, 1982.

Putnam Museum and Science Center. "Mi Nueva Casa: QC Mexican Heritage." Davenport, IA, 2011.

QCmemory.org.

Richardson-Sloane Special Collections Center, Davenport Public Library.

Roba, William H. *Floyd Dell in Iowa, Books at Iowa 44*. Iowa City: University of Iowa, 1986.

———. *There'll Be a Hot Time in the Old Town Tonight: Davenport's Bucktown*. Contemporary Club Papers 83. 1983–85.

Scott County, Iowa Genealogy. www.celticcousins.net/scott/scotthistory.htm.

Smith, Doug. *Davenport: Postcard History*. Mount Pleasant, SC: Arcadia Publishing, 2007.

Snyder, Charles E. "John Emerson, Owner of Dred Scott." *Annals of Iowa* 21, no. 6 (Fall 1938).

State Historical Society of Iowa, Site Inventory Forms.

Svendsen, Marlys. *Davenport: A Pictorial History 1836–1986*. St. Louis, MO: G. Bradley Publishing, 1985.

Bibliography

Wood, Sharon E. *The Freedom of the Streets: Work, Citizenship, and Sexuality in a Gilded Age City*. Chapel Hill: University of North Carolina Press, 2005.

Wundram, Bill, and the *Quad-City Times*. *A Time We Remember: Celebrating a Century in Our Quad-Cities*. Davenport, IA: Quad-City Times, 1999.

Newspapers

Cedar Rapids Gazette
Chicago Record-Herald
Chicago Tribune
Davenport Daily Gazette
Davenport Daily Republican
Davenport Daily Times
Davenport Democrat
Davenport Democrat and Leader
Dubuque Telegraph-Herald
Evening Times-Republican (Marshalltown, Iowa)
Iowa City Press-Citizen
Quad-City Times
River Cities Reader
Rock Island Argus

Most articles can be found by searching access.newspaperarchive.com, the "Historic Newspapers" section of loc.gov, the papers' own websites and the Davenport Main Library Richardson-Sloane Special Collections Center.

INDEX

A

Adler Theatre 16, 18, 66, 78, 80, 81, 82, 84, 104, 107, 134, 136, 138, 150, 158, 160, 164
alcohol 15, 19, 23, 35, 36, 37, 39, 40, 42, 43, 44, 45, 46, 47, 50, 51, 57, 156

B

bars 9, 10
Becker, Ludwig 60, 61, 62, 115
beer 13, 15, 19, 20, 21, 23, 37, 39, 60, 65, 71, 156, 157, 158, 163
Beiderbecke, Bix 29, 31, 59
brewery 9, 17, 156, 157, 158
brothels 10, 13, 19, 32, 48, 49, 50, 51, 52, 54, 55, 56, 89, 90, 164
Bucktown Center for the Arts 7, 9, 10, 18, 91, 92, 93, 94, 147, 156

Bucktown (New Orleans) 32
Bucktown Revue 9, 159, 160
Burtis House 62
Burtis, J.J. 62
Burtis Opera House 18, 20, 61, 62, 63, 64, 65, 164

C

Capitol Theatre 17, 78, 79
Carter, Kyle 12, 16, 17, 18, 95, 140, 141, 147, 150, 155, 163, 164
Clark, William Lloyd 13, 55
Claussen, Ernst 23, 37, 38, 39
Claussen, Hans Reimer 23, 24
Coliseum 60, 62
Cosgrove, Reverend Henry 12, 54, 69, 70, 157
Crescent Macaroni and Cracker Company 62, 117, 142, 143, 144, 145, 152

INDEX

D

dance hall 10, 19, 23, 48, 54, 55, 60, 71, 72, 89
Davenport Municipal Art Gallery 84, 85
Dell, Floyd 13, 21, 89, 90
Depression 73, 79, 114, 119, 121, 131
Disney, Walt 18

F

Ficke, C.A. 24, 42, 84, 85
Figge Art Museum 86, 95, 133, 137
Figge, V.O. 119
Forrest Block 26, 164

G

Germans (or German Americans) 15, 19, 20, 21, 23, 24, 25, 26, 28, 29, 31, 37, 42, 55, 59, 60, 65, 84, 159
Germany 23, 24, 29, 49, 60, 84
Grant, Cary 81, 82, 83

H

Halligan Coffee 93, 145, 148, 149
Hickey Brothers 100, 101, 102, 103
Hotel Blackhawk 16, 17, 80, 82, 103, 104, 106, 107, 108, 109, 112, 113, 118, 121, 131, 132, 133, 136, 140, 141, 147, 150, 160, 164

J

Jolson, Al 18, 65, 88

K

Kimball Hotel 60, 100

L

Lend-a-Hand 51
liquor 14, 35, 36, 37, 39, 43, 49, 68, 70, 158
Looney, John 55, 56

M

McDaniel, George 36, 37, 39, 41
Meeker, Gene 128, 132, 134, 135, 138, 144
Midcoast Fine Arts 92
Miller, Doug 18, 79, 80, 81, 82, 127, 128
Mississippi Hotel (and Lofts) 78, 80
Mississippi River 9, 12, 18, 19, 21, 33, 37, 44, 53, 74, 75, 78, 95, 99, 142, 159
Moon, Edwin 43
mulct law 39, 41, 42, 49, 72
Munro, Brick 11, 18, 20, 65, 71, 87, 88, 89, 90, 91, 92, 97

P

Palmer, B.J. 74, 75
Petersen's 115, 127, 128, 131
Prohibition 15, 32, 36, 37, 39, 43
prostitution 13, 15, 19, 23, 29, 32, 42, 49, 50, 51, 53, 54, 55, 56, 70, 89, 90

INDEX

Q

Quad-Cities 16, 17, 79, 80, 86, 153, 156
Quad City Arts 80, 81, 83, 133
Quad City Symphony Orchestra 18, 60, 80, 160

R

red-light abatement law 56
red-light district 9, 13, 18, 32, 48, 50, 56, 57, 90
Restoration St. Louis (RSL) 107, 109, 113
Richter, August 28
RiverCenter 80, 81, 104, 107, 132, 133, 134, 136, 164
River Music Experience (RME) 26, 95, 136, 137, 159, 160
Riverwatch Place 155
RKO Orpheum 18, 78, 79, 164
Ruhl, John 151, 155

S

saloon 11, 12, 13, 14, 19, 23, 39, 40, 41, 42, 43, 48, 54, 55, 56, 72, 88, 89, 90, 157, 160, 164
Schleswig-Holstein 23, 24, 25, 38
Scott County 13, 15, 23, 29, 36, 37, 41, 42, 84, 106, 153, 163
Simonsen, Jane 23, 48, 49, 50, 51, 52, 53
Storyville 18, 32, 56
suffrage 43

T

temperance 14, 25, 35, 36, 37, 41, 43, 53, 160
theaters 10, 11, 19, 23, 37, 48, 54, 55, 64, 66, 68, 72, 73, 74, 79, 87
Thomson, Jim 140, 141, 147
Tri-City Symphony 31, 60, 61, 66, 115
Turners (and Turner Hall) 25, 26, 27, 28, 37, 42, 84

U

Union Arcade 163, 164

V

Victor, Alexander 59, 75, 76, 77
Vollmer, Henry 28, 29, 46, 49, 50, 52

W

Wittenmyer, Annie 25, 160
WOC 67, 74, 75
World War I 31, 33, 56, 59, 84, 114, 116, 142
World War II 102, 114, 122, 124, 126, 127, 145

ABOUT THE AUTHOR

Courtesy of Meg McLaughlin.

Jonathan Turner is an arts and entertainment reporter for the *Dispatch* and the *Rock Island Argus* (Moline, Illinois), for which he has written since 1995. During his professional journalism career, he's also written for daily and weekly papers in Connecticut. An active piano player in the Quad-Cities, he is a regular accompanist at Zion Lutheran Church and the *Bucktown Revue* in Davenport and has played for many musicals, receptions, weddings and other events. His original musical, *Hard to Believe* (based on the Book of Job), was performed at Playcrafters in Moline in 2010. You can see more of his writing at Facebook.com/JTreporter. He lives in Bettendorf, Iowa, with his wife, Betsy, and sons, Josh and Alex.

Visit us at
www.historypress.net

This title is also available as an e-book